IMAGES
of America

MURRIETA
HOT SPRINGS

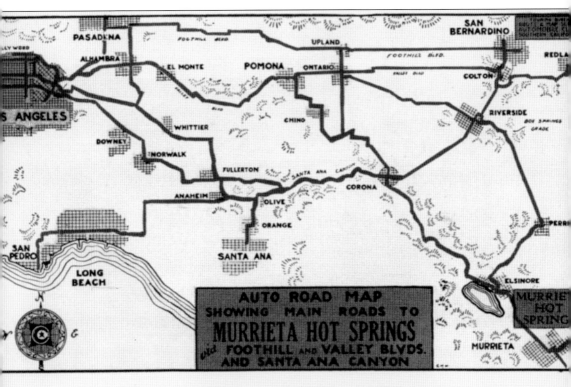

POSTCARD MAP TO MURRIETA HOT SPRINGS, c. 1920. The Automobile Club of Southern California provided this map to the postcard publisher, showing routes widely used today by commuter traffic on eight-lane freeways. The populations of "Holly Wood" (Hollywood), Ontario, Corona, and Orange were much smaller than those of Murrieta, Perris, San Bernardino, and Santa Ana.

ON THE COVER: This typical scene of visitors in front of the Guenther's Murrieta Hot Springs office, with Memorial Hall in the distance, was captured by photographer Edward Noble Fairchild, who took scores of pictures at the resort during the 1920s and 1930s. This book features 20 of Fairchild's artistic photographs from Tony Guenther's collection. Many of his images were reproduced on postcards. (Courtesy Tony Guenther.)

IMAGES of America
MURRIETA HOT SPRINGS

Rebecca Farnbach, Loretta Barnett,
Marvin Curran, and Tony Guenther

Copyright © 2008 by Rebecca Farnbach, Loretta Barnett, Marvin Curran, and Tony Guenther
ISBN 978-0-7385-5956-8

Published by Arcadia Publishing
Charleston SC, Chicago IL, Portsmouth NH, San Francisco CA

Printed in the United States of America

Library of Congress Catalog Card Number: 2008928315

For all general information contact Arcadia Publishing at:
Telephone 843-853-2070
Fax 843-853-0044
E-mail sales@arcadiapublishing.com
For customer service and orders:
Toll-Free 1-888-313-2665

Visit us on the Internet at www.arcadiapublishing.com

This book is dedicated to Fritz Guenther for his visionary work in developing Murrieta Hot Springs into a world-class resort and to Hugo Guenther for his humanitarian service and integrity. From left to right, Fritz's grandson Frederick Hugo "Bud" Guenther, Fritz's son Hugo, and his great-grandson Tony looked at Guenther's Murrieta Hot Springs Resort from Hugo's hilltop home.

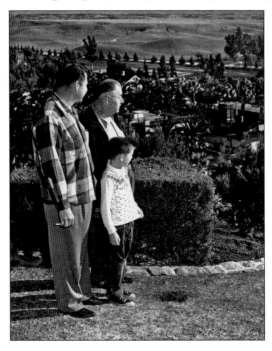

Contents

Acknowledgments		6
Introduction		7
1.	All Roads Lead to the Hot Springs	9
2.	Mud, Steam, and Hot Water	25
3.	What They Did for Fun	45
4.	From Tents to Luxury Hotels	69
5.	The Visionary Guenthers	93
6.	From Teamsters to Polarity	105
7.	Restoration by Calvary	115

Acknowledgments

We are indebted to scores of people without whose encouragement, contributions of time, photographs, and information this book would not have been possible. We thank Pastor Chuck Smith and others at Calvary Bible College, especially Karl Bentz, Joel Wingo, Robin Lewis, Jeff Dorman, and Stephen Pepenella.

We appreciate the help from Lisa Woodward and the Pechanga Band of Luiseño Indians for sharing their part of the story. Thanks to the Guenther family, Malcolm Barnett, David Barnett, Skip Allen, Murrieta Guenther Lohr, Mary Von Moos, and Peggy Goffman for sharing information about the Guenther era and beyond. We extend our gratitude to Billy Riley and Teresa Thorne for telling their stories about the teamsters era. We thank Paul Price for sharing information.

We thank Haimish Music (BMI) for allowing the use of the lyrics to "Murietta Hot Springs," Len Freedman for his assistance, and Hal and Sylvia Schwartz for translating the Yiddish phrases. We appreciate research assistance from James Fairchild, Kevin Hallaran, Michele Nielson, Bob Gregory, Ethel Barnes, Roger Osenbaugh, and Charles Johnson.

Previous works about Murrieta that aided us include Horace Parker's *The First 60 Years*, *Guenthers Murrieta Hot Springs*; Arlean Garrison's *My Children's Home*; Mary Alice Rail Boyce's *Murrieta, Old Town, New Town*; and Steve Lech's *Along the Old Roads*.

We thank Norma Wilson for her technical assistance and moral support, Keith Reekie for his editorial expertise, and our proofreaders, Dick Fox, Bill Harker, and Darell Farnbach. Hugs to Debbie Seracini and others at Arcadia Publishing for helping us produce this book.

Thank you to the following who donated images: Judy Guenther Cole (JGC), Murriela Guenther Lohr (MGL), Fred Guenther (FG), Cathy Begley Hanson (CBH), Malcolm and Loretta Barnett (MLB), David and Paula Barnett (DPB), Temecula Valley Historical Society (TVHS), Darell and Rebecca Farnbach (DRF), Virginia Blake VanCamp (VBV), Robin Steely (RS), Billy Riley (BR), Sam and Ethel Barnes (SEB), and Joel Wingo at Calvary Chapel Bible College (CCBC). Unless otherwise noted, all photographs and postcard images are from Tony Guenther's collection.

There are unnamed others who lent us moral support and pointed us toward helpful resources. We sincerely thank each of you for helping us with this book, which was, for us, a labor of love.

INTRODUCTION

Churúkunuknu Sakiwuna (a name from two roots meaning "sliding and lifting"), as the Luiseño Indians call the Murrieta Hot Springs, was visited by *Wúyoot*, who, according to the Luiseño creation legend, was born to *Túukumit* (night) and *Tamáayawut* (earth). He was one of the first people and was the last child born to them. Wúyoot provided food, taught the people how to live, and gave them ceremonies. He was also the first to die, and before him, death did not exist. After Wúyoot was poisoned by *Waxáawut* (Bullfrog), he traveled to several local hot springs in an attempt to be cured. Churúkunuknu Sakiwuna (Murrieta Hot Springs) was the fifth spring he visited before the last, *'Iténgvu, Wumówmu* (Lake Elsinore). There are conflicting accounts of where he died and was cremated. One location is *'éxva Teméeku*, near the present-day Old Town Temecula.

Several accounts say the Luiseño people did not go into the hot spring water, possibly for reasons linked to the above creation story. They may have considered the waters sacred. In the early 1900s, some local Native Americans said they believed they should not bathe in the waters because harmful "water babies" lived in the hot springs.

After Europeans entered the Temecula Valley, they recognized the curative and cleansing powers of the bubbling hot mineral spring waters. Man and beast dipped into the pools to heal sores. Juan Murrieta, who bought the Temecula Rancho with partners Francisco Zanjurjo and Domingo Pujol in 1873, dubbed the region "Murrieta Hot Springs." Murrieta cleaned his wool before shearing by bathing the sheep in the springs. In 1887, the Murrieta Steam Laundry shipped dirty clothes from San Diego for washing in the springs with a three-day turnaround by train.

After Dr. Henry Worthington from Los Angeles declared the healing attributes of the mineral waters, visitors came to bathe in the health-giving springs. San Diegan Alonzo Horton promoted it as a Fountain of Youth after restoration of his hearing from treatment in the mineral springs.

Fritz Guenther, a German emigrant, sold his saloon in Los Angeles and bought acreage surrounding the three springs in 1902 to develop into a world-class health spa resort. Clientele, especially Jewish people familiar with European spas, came by train for long luxurious vacations at the isolated resort, where service staff catered to their whims. They escaped pressures of everyday life by relaxing in bubbling mineral springs and lounging in mud baths, playing miniature golf and tennis, and swimming. Dining tables laden with tempting food accompanied generously available libations, even during Prohibition. During evening hours, people danced, played pool or cards, and smoked. Accommodations were posh, and the entertainment was glorious, from ragtime to big bands, according to the era.

Guenther drove his motorized bus to the Murrieta rail station twice a day to pick up visitors. He housed them in the three large hotel buildings that replaced the original tents of the resort. Famous entertainers and athletic icons frequented the resort. Residents of nearby Murrieta provided service and labor to the resort. Many old-time Murrieta families drew income from employment as waiters, musicians, chambermaids, laundry maids, dishwashers, cooks, barbers, desk clerks, pool guards, butchers, dairymen, gas station attendants, accountants, or mechanics.

A quick frame in Buster Keaton's silent movie *The Cameraman* showed a directory of an office building listing "Murietta Hot Springs, Inc." and "MGM Offices." The varied spellings of Murrieta were common, and the listing was probably an actual office in Los Angeles at the time.

Mickey Katz celebrated his enjoyment of the resort and poked fun at clientele like himself in the following song: (Yiddish words are italicized and translations are in parentheses.)

Murietta Hot Springs (in English and Yiddish)
Lyrics by Grace Eppy and Nat Farber; As sung by Mickey Katz

In New York there are the Catskill Mountains,
Fallsburgh and Ferndale keeps you young
But out in California, the land of milk
 and *honya* (honey),
The Catskills are too far *folg mir a gong*
 ("it's too far for me").

Menschen (people) by the thousands
From New York and far off places,
They go to Murietta
Dortn bakt men op di plaitzes
 (there they bake their shoulders).

In Murietta, in Murietta,
Ale yidn lebn zich a dort (all the Jews live there).
No duner or bliz (no thunder or lightning),
Just itch und shvitz (and sweat)
Dortn shpilt men kortn und shports
(there they play cards and sports).

They're skinny *und fet* (and fat) there in Murietta.
They come to take a *bana* (bath) in the mud.
They're from Chicago and all points east,
It's hard to say the Easterners are bored.

They live it up in hunya,
The seltzer is terrific.
They're all sizes in disguises,
Oy, such fancy *pipiks* (bellies).

Folks, the food is wonderful
Right up to their *gederem* (guts).
I know the food ain't kosher,

'Cause *zey esn vie chazerem*
 (they eat like pigs).

In Murietta Hot Springs,
Like cowboys without *ferd* (horses),
Zey lign (they lie) in the mud baths
Mitn kop in drerd (with their head in the earth).

But it come Saturday night
In dance hall, they're all there
Grab your partner *Shloimele* (diminutive of Solomon)
And we'll do our *Yiddish Sher* (a dance like a reel).

They samba and they mambo
And they *shokl* (shake) to the rumba
They *shokl mit di plaitzes* (shake with their shoulders)
And they *shokl mitn bumbe* (shake their behinds).

There's *beiglech* (bagels)
From Sioux City and Seattle by the dozen
They come to California
And never for a *chosen* (husband).

They wear bikini bathing suits
Those dainty little things
Keyn ain hora (a phrase to ward off the evil eye)
 such *gesunte* (healthy types)
They don't need water wings.

In Murietta Hot Springs
A *shidach* (match) can be made,
For that's the place where honeymooners
Go up in the shade.

 The Guenther family sold the property in 1970 to businessman Irvin J. Kahn, who had ties with the Teamsters Union. His lawyer Morris Shenker later joined him as a co-owner. They constructed a mobile home park on the hills above the resort. Because 99 percent of the original occupants were Jewish, the Congregation B'nai Chaim started meeting in 1973 and built a synagogue next door. Kahn and Shenker renovated the traditional family resort and marketed it as a recreational spa where they hosted golf and tennis tournaments. After the tragic and unexpected death of Kahn, the property went through several owners with limited financial successes until Calvary Chapel of Costa Mesa purchased it and renovated it for use as a Bible college and conference center in 1995.

 Where patrons of the Murrieta Hot Springs once took to the healing waters for relaxation and restoration of health, students now reside in dormitories and take classes to prepare them for Christian work in the outside world. The communities of Temecula and Murrieta are delighted with Calvary Chapel's conscientious and beautiful renovation of the grounds and buildings, reminiscent of the resort's past glory.

 We authors have attempted to capture and represent the essence of each era of "The Springs" we uncovered during our extensive research. If we have overlooked significant people or events, it is because we have striven to give thorough and solid information from resources at hand.

One

ALL ROADS LEAD TO THE HOT SPRINGS

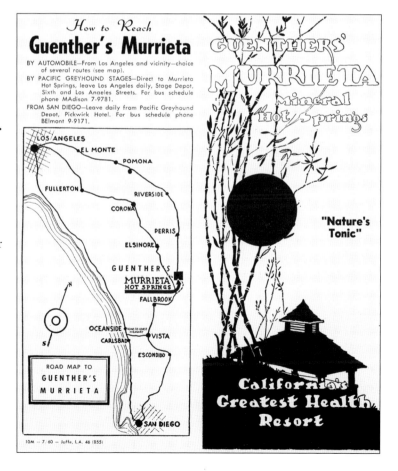

BROCHURE, C. 1950S. The healing mineral waters of the Murrieta Hot Springs have attracted travelers from time immemorial. From the first Native Americans to discover the healing waters, people have wanted to know how to get to the mineral springs. Roads replaced early rabbit trails. Footpaths widened to wagon roads and highways. The following pages show roadways and the early vehicles that traveled to the resort. (DPB.)

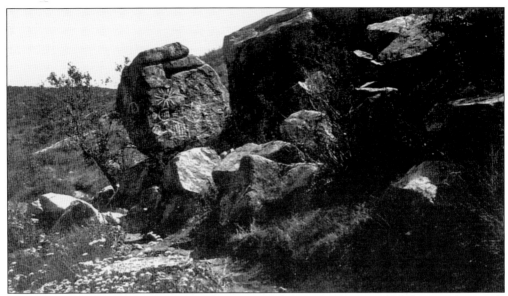

EVIDENCE OF EARLIER RESIDENTS. Early visitors to the Hot Springs would follow winding trails to low cliffs to find Native American paintings (pictographs) on rocks and evidence of an old village site with several grinding holes. Deep holes in the bedrock were used for grinding acorns and small animals, like rats and mice. Shallow holes were used for grinding seeds. (CBH.)

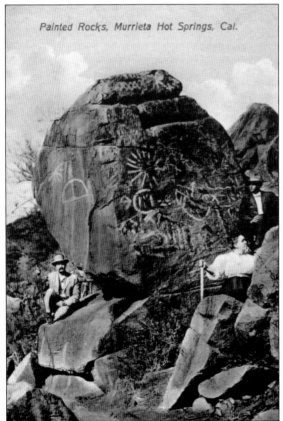

A SAFE PLACE. A Temecula Valley Land Company brochure printed in 1888 stated the rocks near the springs inscribed with "legible hieroglyphics" declared members of warring tribes were safe while partaking of the beneficial waters. Today Pechanga tribal cultural authorities say the meanings of messages are not known and that trespassing was not taken lightly.

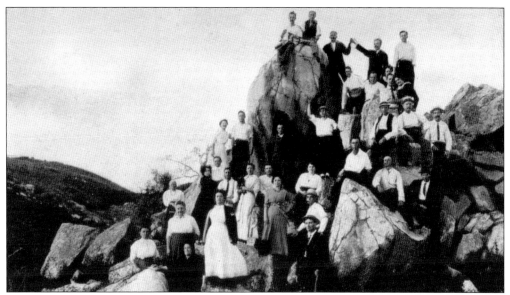

A LAND RICH IN NATIVE TRADITIONS. The path circled the hill from Cripple Creek to Kidney Springs and pointed to the paintings near the grinding rocks on the hill. The design motif on the rocks resembled the San Luis Rey–style painting done where female youth rituals were performed. This postcard was dated 1913.

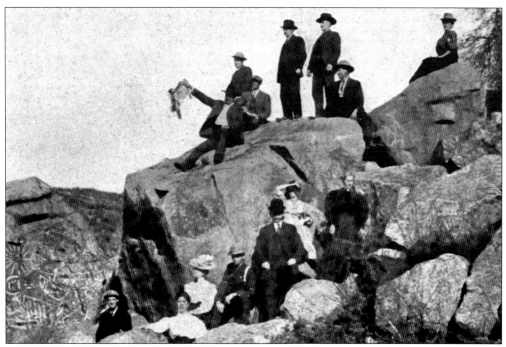

A PLACE TO SEE. A man held a hawk by the feathers while other hikers posed in their Victorian clothing at the Painted Rocks. Fusco Brothers Taxi later added an advertisement on the rock. This important heritage site was destroyed in the 1970s, when Irvin Kahn cleared the area to develop the present-day Murrieta Hot Springs.

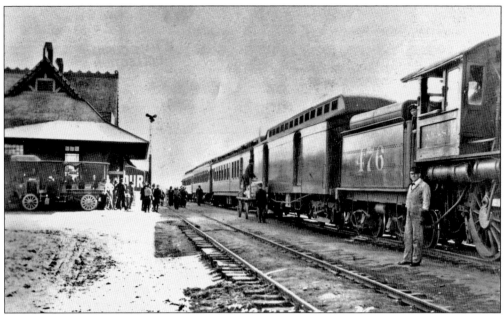

COMING BY TRAIN. Fritz Guenther met visitors from Los Angeles at the Santa Fe train station in Murrieta twice a day and transported them in his open Reliance bus, pictured at left. In 1904, the round-trip ticket from Los Angeles cost $3.20 and was good for 30 days. When a large group was coming, the Santa Fe added an extra car, and Fritz supplied an orchestra for their travel entertainment.

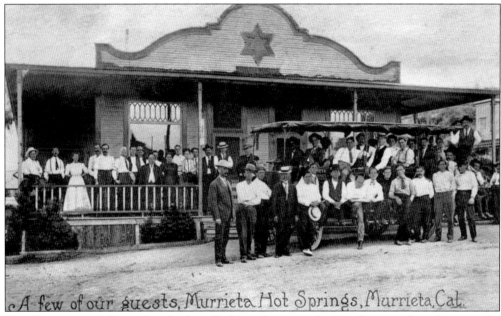

THE CARPENTER'S STAR. Jewish clientele felt welcome at the Hot Springs when they saw the six-pointed star. Fritz maintained it was never intended as a Star of David but that it was the easiest star for a carpenter to fashion. Hugo Guenther sent this postcard from Murrieta to his mother, Louise, on Bonnie Brae Street in Los Angeles on April 11, 1910, for 1¢ postage. His message was in German.

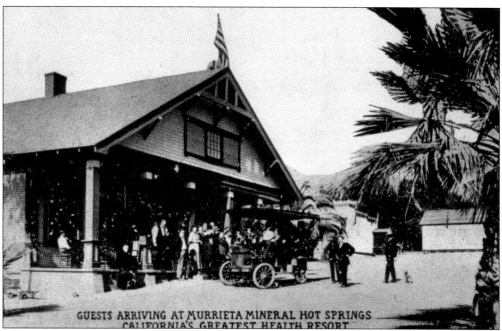

FRONT OFFICE, BEFORE 1914. The printed text on another postcard from this series read, "Bath Houses in Murrieta where thousands have been cured of rheumatism and stomach troubles." Below it was written, "Feeling fine. Will be home Tuesday evening—Lawrence." A note was added by another hand, "From Lawrence while he was gaining his health in Murrieta."

OLD RANDOLPH BUS. When Fritz Guenther picked up his earliest guests at the Santa Fe Railroad Station, he transported them to the springs in a horse-drawn, three-seated surrey. This motorized bus was an improvement. Notice the dependable solid rubber tires. They didn't give a comfortable ride, but they also didn't go flat.

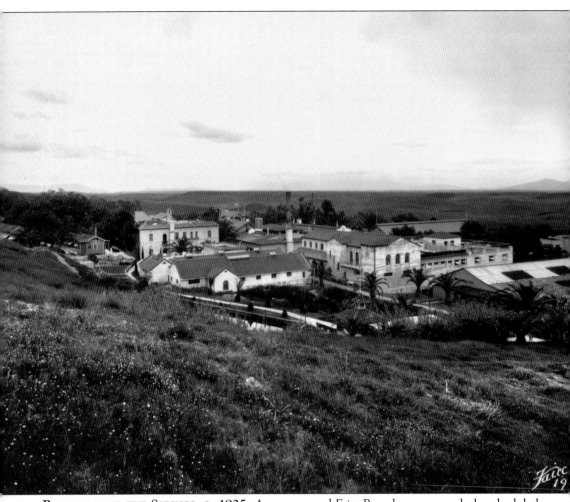

PANORAMA OF THE SPRINGS, C. 1925. A man named Fritz Beyerle ran a regularly scheduled "stage route," or motorized bus service, to the springs from the corner of Fifth and Los Angeles Streets in Los Angeles. Pickwick Stages bought out Beyerle's line and became Inland Stages. They eventually sold to Greyhound Bus Lines. A visitor saw the undulating hills of Southwest Riverside County, at an elevation of about 1,100 feet, after the long ride from Los Angeles. The lonely road, open fields, and grazing cattle dominated the landscape until they arrived at the resort and saw sizable buildings. The covered pool, or "plunge," was the building with skylights on the right, and Big Springs was near the gazebo in the foreground. The Depression started shortly after the resort was completed, and no major construction was done for the next 30 years.

A LAND OWNED IN SUCCESSION. Native Americans watched while foreigners came in and carved out plots and claimed ownership of traditional hunting lands, including what later became known as the Murrieta Hot Springs. In 1844, the Mexican government awarded the Temecula Rancho to Felix Valdez. Louis Vignes purchased it in 1852, and Juan Murrieta bought it from him in 1873. Murrieta sold it to Moses Perin in 1883, who sold it to a Pasadena syndicate in 1887. Fritz Guenther purchased Murrieta Hot Springs from a Mrs. Lindsay in 1902 with the dream of making it into a world-class resort spa like ones he had seen in Europe. Before personal automobiles changed the way Americans vacation, families would pack large trunks to take on the train for lengthy stays at resorts. The idea was to get away from the city, to breathe fresh air, and to stay away from the troubles at home.

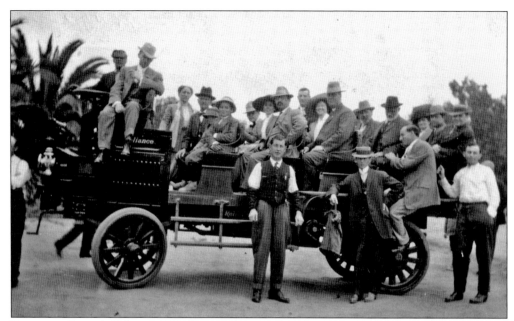

RELIANCE BUS. A Reliance bus was used for a while to transport guests to and from the train station. Hugo Guenther, in short sleeves and wearing a vest, is in the center of the photograph, in front of guests who were either arriving or departing from the springs. The attractions of the springs included mud bathing, biking, hunting, horseback riding, throwing horseshoes, swimming, dancing, people-watching, and games such as badminton, croquet, and billiards.

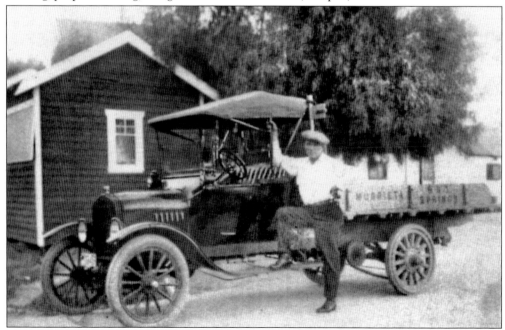

BILL HACKENBERG'S MODEL T TRUCK, 1917. This vehicle carried freight. It featured solid rubber tires and a chain drive to handle heavy loads. The sign on the side of the truck read, "Murrieta Hot Springs." Although the springs provided much of the supply of meat, dairy products, and produce, they did need deliveries of other items, which came from Los Angeles.

PICKWICK STAGE. This "stage line" provided transportation for passengers between El Paso, Texas, and Seattle, Washington. This particular tour bus most likely followed an inland route from San Diego to Los Angeles. Under the roofline on the side of the bus are the words, "El Paso–San Diego–Los Angeles–Pickwick Stages–San Francisco–Portland–Seattle." On the front of the bus, a movable placard says, "Los Angeles to San Diego."

GUESTS' AUTOMOBILES, 1933. Automobiles of guests lined the street in front of the Annex Hotel in this photograph by Waldo Henry Dingman Sr. Barney Firks and his mother drove to the springs in his 1922 Essex in 1924 and stayed for a week. The $18 fee for each of them provided three good meals each day with wonderful milk, cream, steaks, and pies.

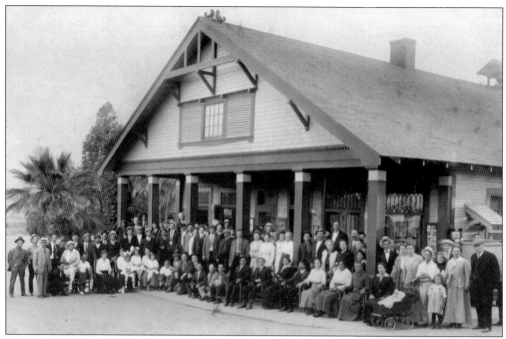

GUESTS BY OFFICE. Nearly 100 guests posed in front of the office. The dining room and kitchen were behind the business office. It is believed a blind pig saloon operated in the basement during Prohibition. The office was torn down in the 1990s, and the decorative windows have been reused in Calvary Chapel's Hospitality Room. (JGC.)

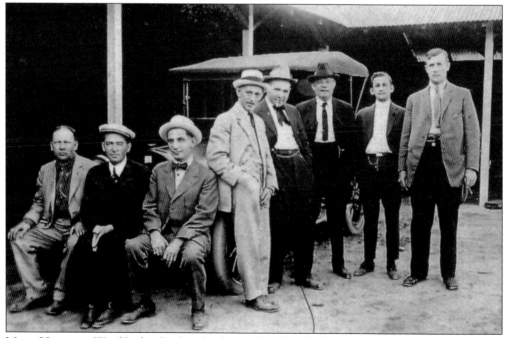

MALE VISITORS. Word had it that bootleg liquor flowed at the hot springs from a source in French Valley. It is believed there was a speakeasy in the cellar under the dining room and kitchen. Moveable panels in the Submarine malt shop hid slot machines that were used up into the 1940s.

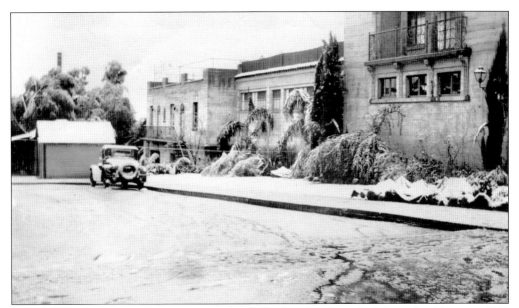

SNOW AT THE HOT SPRINGS, 1949. It didn't look like a Southern California health spa in 1949 when the Mineral Bath House and Laundry and their surrounding landscape shivered under a rare covering of snow. Heavy snows also fell in 1956 and 1957. The laundry building, formerly run by Hazel Johnson and Jessie Cooper, is still in use. Claire Zimbo worked in the bathhouse.

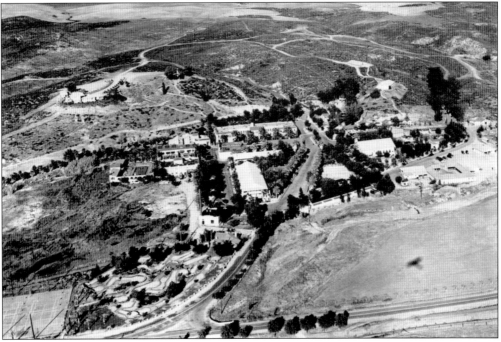

AERIAL VIEW. The shadow of the photographer's airplane darkened an area in the right foreground from the airstrip in this view. Along the left front were the tennis courts and miniature golf course. Mud for the baths was harvested from the field above the tennis court. Hugo Guenther and his family lived in the large house on the hill in the left background. Horse stables were located near the airstrip.

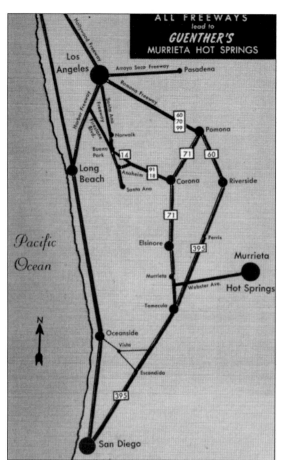

FREEWAYS LEADING TO THE HOT SPRINGS. Highway 395 was constructed through the area in 1949, linking Mexico to Canada. The roadways depicted on the postcard map follow the same routes as the ones we drive today, but the new numbers reflect the connection with the interstate highway system. In 1950, the name of Webster Avenue was changed to Murrieta Hot Springs Road to help motorists find the springs.

MONTEREY BUNGALOWS. This postcard (below) boasts of "a group of popular bungalows with private showers." The 1947 Chevrolet and other automobiles date the era when the photograph was taken. The Mineral Bath House was visible behind the bungalows, and the Mud Bath House stood at the end of the road. Employee housing units were built behind the bungalows. Employee benefits included room and board.

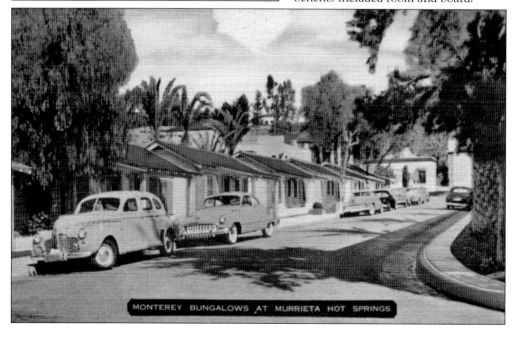

VEHICLES AND GARAGE, C. 1914. From left to right, an open touring car, the Guenther Bus, and Rudy Guenther's Stutz rested near the springs garage. The resort offered Red Crown gasoline and automotive repair to visitors whose automobiles required service after the rough ride through the countryside. The old barn and horse stables peeked from behind the left side of the garage.

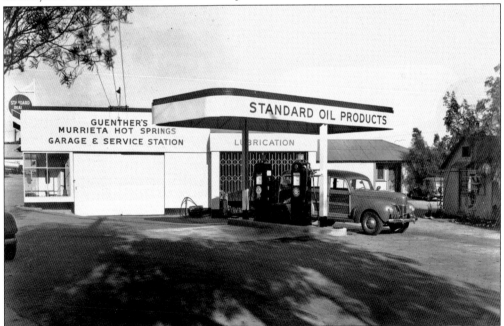

GARAGE AND SERVICE STATION, LATE 1940S. Cars needed gasoline and servicing after the long drive to the springs. The station also offered covered parking spaces for guest vehicles. Bicycles were available for rent. In the 1940s, regular gasoline sold for 17¢, and premium gasoline, called ethyl, sold for 19¢ a gallon. Stations like this gave away free maps and other gifts to motorists.

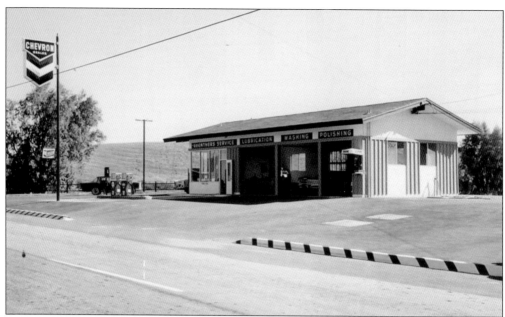

CHEVRON STATION, 1960s. This station near the entrance of the springs offered full service, meaning an attendant pumped gasoline, washed windows, and checked fluid levels and tire pressure for each customer at no additional charge. The price of gasoline was approximately 38¢ a gallon. The building later served as a real estate office. The hills behind have been leveled, and today new retail buildings and homes flank the location. (TVHS.)

HOT SPRINGS LANDING STRIP. Facilities changed to accommodate demands, from foot traffic to horse-drawn vehicles, automobiles, and airplanes. By the 1960s, guests occasionally arrived in small private planes on the landing strip of packed soil. A wind sock flew there, adjacent to the golf driving range and parallel to Murrieta Hot Springs Road.

OVERVIEW OF THE SPRINGS. In the early years, a two-lane road brought guests to the quiet peaceful countryside to enjoy healing waters and clean air. A monument dedicated to Fritz Guenther once stood amid a garden at the top of Memorial Hill. It was a good hike up to the monument, which was near the flag seen above the trees. The monument is now located in nearby Pond Park.

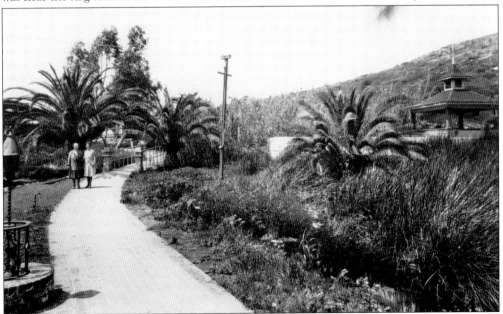

GARDEN WALK BY BIG SPRINGS POOL. Two unidentified women lingered along the garden pathway near the Big Springs Pool and the gazebo on the right. The pathway over the bridge behind them led to Cripple Creek and Kidney Springs. Notice the ironwork path light to the left, set into a decorative base. Fritz Guenther's son, Rudy, was responsible for the resort's artistic flourishes, while son Hugo ran the business operations.

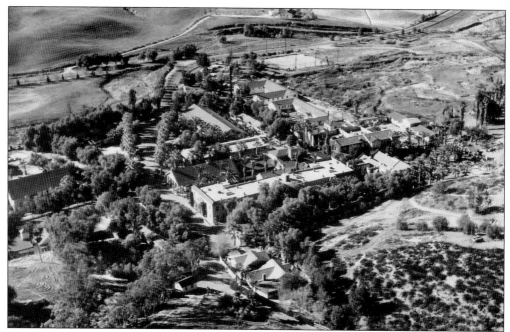

AERIAL PHOTOGRAPH, LOOKING WEST. Fritz Guenther's daughter Annie Bergey and her family lived in the home at the top of the photograph, just right of center. Tule mud was dug from the area of the upper right using sickles or mowing machines. Large chunks of mud were chopped into smaller pieces, grass and all, and were taken to tubs for mud baths.

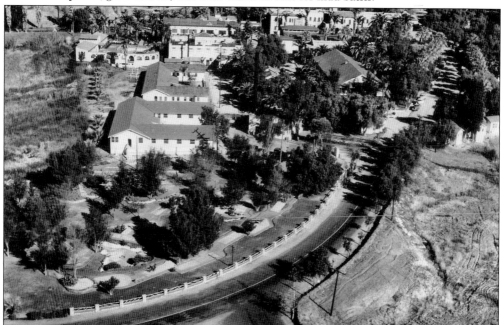

SWEEPING VIEW OF ENTRANCE. Many of the employees of the hot springs lived on the resort and enjoyed eating in the workers' dining room. There were up to 185 employees at times, who served as many as 500 guests. Workers lived in dormitories and in cottages. Some employees worked as long as 40 years at the resort.

Two
MUD, STEAM, AND HOT WATER

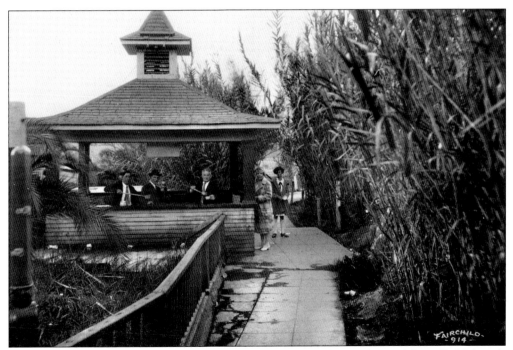

HOT MINERAL SPRINGS WATER. Four hot mineral springs—the Big Spring (also called Siloam), Beauty Spring (Ramona), Cripple Creek (Radium Spring), and the famous Kidney Spring—were formed by geological faults, which run through the region. Here guests took healthy draughts of mineral water from the large dippers provided for that purpose.

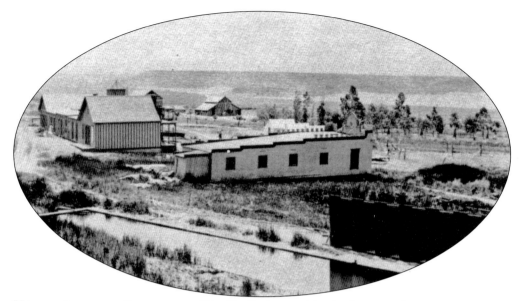

VIEW OF POOL AND BATHHOUSES. The Big Spring pool in the foreground was never a success because of problems maintaining a comfortable water temperature. Weather-beaten dressing rooms were in the right foreground, the Mud Bath House was in the center, and Cottage Row was on the left. The old barn in the background was used for farming operations.

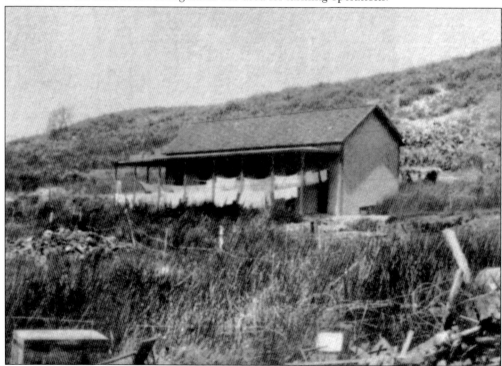

MINERAL WATER BATH HOUSE, 1904. People flocked to the healing springs in Murrieta after their physicians read Dr. Henry Worthington's testimonials in the Southern California Practitioner medical journal. He gave an account of his visit to the springs and of the benefits of the mineral waters. The hot springs averaged between 110 to 140 degrees Fahrenheit.

CRIPPLE CREEK, 1904. When guests first soaked in Cripple Creek, they shaded themselves with blankets thrown over a fence. Minerals including calcium, magnesium, sodium, potassium, bicarbonates, chlorides, fluorides, and boron naturally enriched the water for therapeutic uses. The mineral water soak softened a person's skin and relaxed sore muscles.

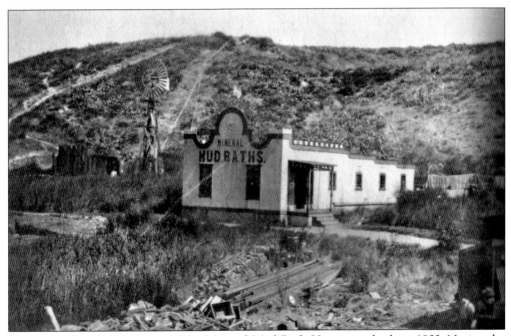

MINERAL MUD BATH HOUSE. The Mineral Mud Bath House was built in 1903. Notice the construction materials in the foreground. A windmill stood proudly next to the building, giving fresh, sweet water to the resort from a well below. Rich mineral mud was harvested for the mud baths from the tule marsh in the foreground.

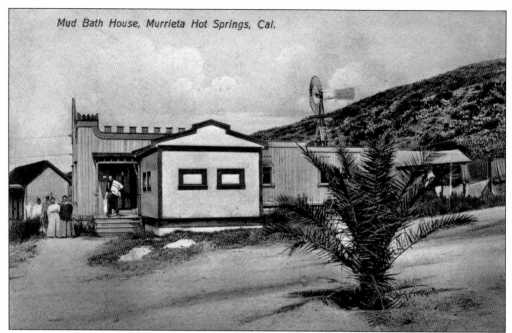

MUD BATH HOUSE, 1911. This was advertised as a place where the people could leave all of their ailments in the mud. Many new buildings had been added, attendants catered to guests, and over the next several decades, the resort became famous. Physicians, including a Dr. Mudd, resided on-site and were available to guests.

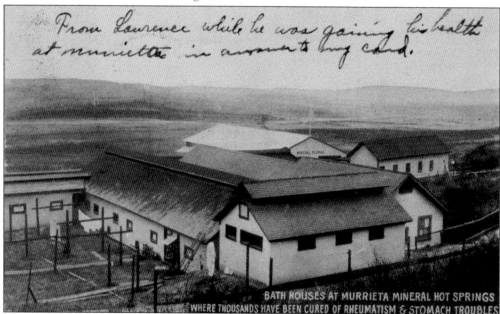

BATH HOUSES AND COVERED PLUNGE, 1914. A postcard reads, "From Lawrence while he was gaining his health at 'Murrietta.'" Claims were made that a stay at Guenther's Murrieta Hot Springs and visits to the bathhouses would cure nervousness, rheumatism, alcoholism, and liver, kidney, and stomach problems. Alonzo Horton claimed that he had been cured of hearing problems after a few days in the mineral waters.

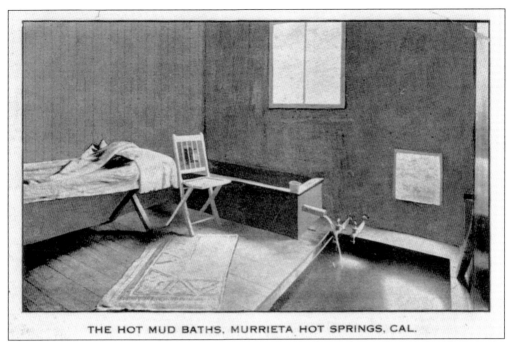

THE HOT MUD BATHS, MURRIETA HOT SPRINGS, CAL.

HOT MUD BATHS. Soothing hot baths or thick mud and tule mash were believed to draw toxins and impurities from the body. Guests often enjoyed massages after the baths, and then they would nap in the sunshine. An ice-water salt pack for the forehead cost 25¢.

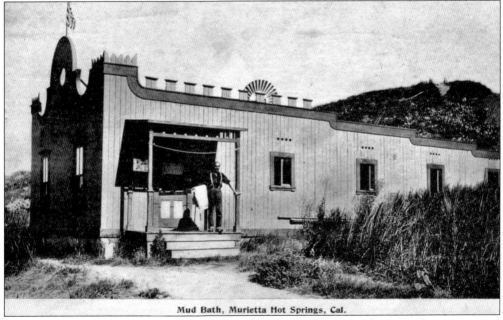

Mud Bath, Murietta Hot Springs, Cal.

ATTENDANT HOLDING TOWEL. In the 1880s, there was a plan to develop a nearby town named Lindon, which was to be settled by Quakers. Each house was to have hot and cold running water, with the hot water supplied from the mineral springs, so an invalid could rent a house and get his medicine from the faucet. Neither the town nor the piping of hot water from the springs materialized.

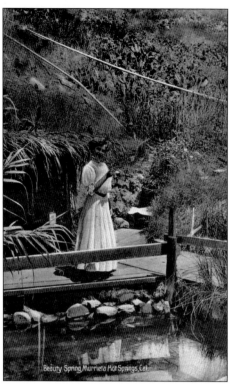

BEAUTY SPRING. A lovely young lady enjoyed a cup of the hot mineral water from Guenther's Murrieta Hot Springs, the springs with a reputation for providing relief from physical ailments. The verdant and beautiful setting with wholesome food and entertainment gave an atmosphere of tranquility and serenity. During the early days of the springs, Hugo and Rudy Guenther entertained guests with gymnastics, dancing, and playing the mandolin. (MLB.)

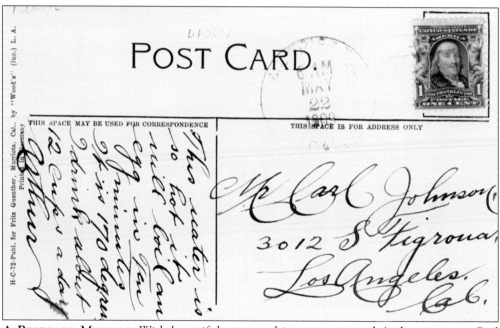

A POSTCARD MESSAGE. With beautiful penmanship, a man named Arthur wrote to Carl Johnson in Los Angeles this message dated May 22, 1909: "This water is so hot it will boil an egg in ten minutes. It is 170 degrees. I drink about 12 cups a day." Like Epsom salts, the mineral water had cathartic properties, so he probably experienced inner cleansing from drinking the water. (MLB.)

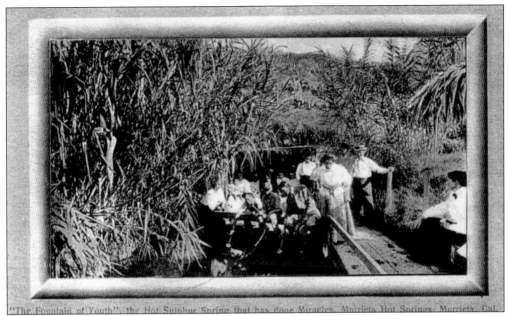

"The Fountain of Youth", the Hot Sulphur Spring that has done Miracles, Murrieta Hot Springs, Murrieta, Cal.

"THE FOUNTAIN OF YOUTH." The hot sulfur spring was noted for miracles attributed to drinking its waters and soaking in it. Thousands of people claimed to have been cured by the healing mineral water. Many actually enjoyed the taste of the water. Was it the water or the setting? The relaxed atmosphere of the springs gave a feeling of time passing in slow motion.

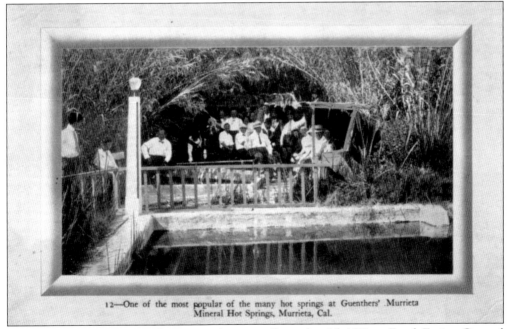

12—One of the most popular of the many hot springs at Guenthers' Murrieta Mineral Hot Springs, Murrieta, Cal.

A POPULAR HOT SPRING. This postcard, sent on December 15, 1911, to Frank Furins, General Delivery, Washington D.C., shows male guests in white shirts and ties and ladies in all of their finery at the recreational location. This, nature's inspiration for later hot tubs, was one of many in the Elsinore Fault region. Others that developed into resorts included Gilman, Warner, Soboba, and Elsinore Hot Springs.

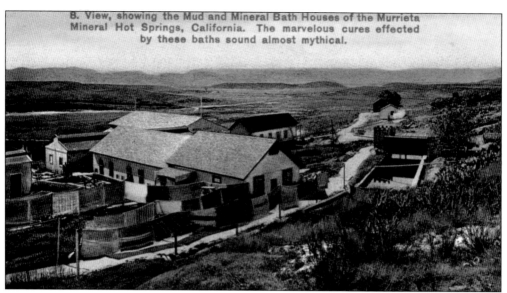

8. View, showing the Mud and Mineral Bath Houses of the Murrieta Mineral Hot Springs, California. The marvelous cures effected by these baths sound almost mythical.

MUD AND MINERAL BATHHOUSES. Early accounts of the hot springs described a large pool, 8 feet across and 3 feet deep. The water was so clear that the bubbles of gas and steam could be seen rising from the bottom. The flow was very strong, and the water was so hot that a man would be parboiled if he dropped into it.

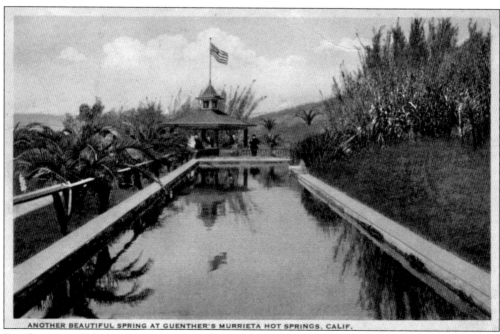

ANOTHER BEAUTIFUL SPRING AT GUENTHER'S MURRIETA HOT SPRINGS, CALIF.

BIG SPRINGS. Other waters were plentiful in the area besides the springs. An 1886 *Los Angeles Times* article told about a subterranean body of water near Murrieta, where the author crawled, slid, and traveled on a plank boat along a two-mile, dark, underground passageway until he resurfaced through a tunnel.

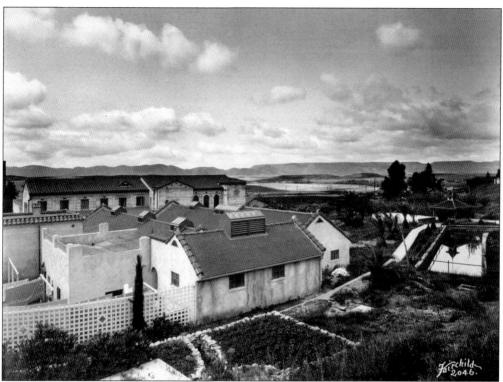

LAUNDRY AT THE HOT SPRINGS. Sunshine was a valued commodity in Southern California. This postcard, dated 1929, showed sheets and blankets hanging in the fresh air in the days before electric dryers. Vegetables were grown in the gardens in the foreground. Skylights were used to illuminate buildings, giving a warm and cheery atmosphere. Invalids came from the East to recuperate by sitting in warm sunshine.

KIDNEY SPRINGS. Judy Guenther remembers rushing home from school in the 1950s with her brother Carl so they would have time to swim before the pool closed for the evening. Then, as a treat, her family would take a walk through the resort to sample water from each of the springs. They loved drinking the water, especially when they added salt to it.

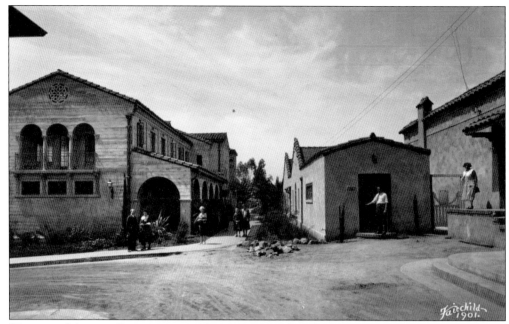

NEW AND MODERN BATHHOUSES. The new Mineral Bath House on the left opened in 1928, and the Mud Bath House was completely remodeled in 1929. The second floor of the Mineral Bath House held a gymnasium that was later used for showing fairly recent movies in the 84-seat theater. George Blake, the office manager, stood by the Mud Bath House door.

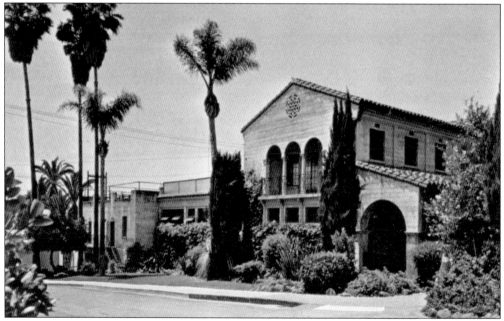

AN OLD WORLD CURE FOR MODERN-DAY PROBLEMS. In the fashion of German spas, the springs facilities stood the test of time. Mature landscaping enhanced the grounds of the resort, a city within itself. Gardeners kept the grounds manicured to perfection. Office clerks, waiters, cooks, bakers, carpenters, painters, electricians, plumbers, maids, laundry personnel, and business personnel ran a smooth operation.

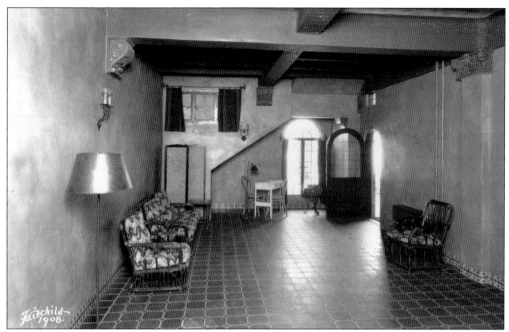

ENTRANCE TO MEN'S MINERAL BATH. The beautiful tile work and furnishings in the lobby are examples of the care taken to provide a comfortable setting for guests. Inspiration for the decor came from Spanish, Italian Renaissance, and Moorish influences. The tile surfaces were easy to keep clean and sanitary.

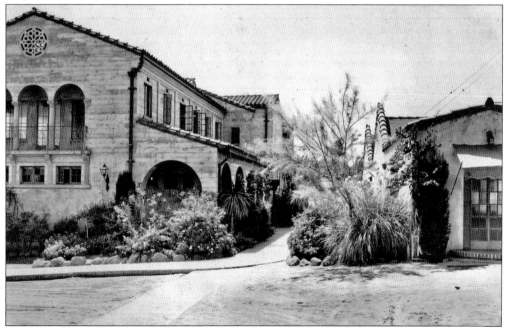

MINERAL AND MUD BATH HOUSES. By 1964, Guenther's Murrieta Hot Springs advertised a first-of-the-week special. Fees started at $28.50 per person, with two people to a room. This included breakfast and dinner, swimming, dancing, and movies. Mineral and mud bath charges were extra. The Guenther children all worked at the resort and enjoyed knowing the employees and guests.

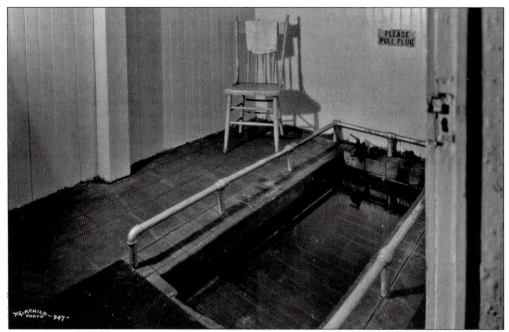

INTERIOR OF EARLY MINERAL BATH HOUSE. After a relaxing mineral bath, many guests would lie on a table covered with a sheet to cool off and take a nap. A salt pack was placed on their forehead to replace the lost body salts. Notice the sign that reminds guests to pull the plug. The mud was reused multiple times, but fresh water was added to it for each guest.

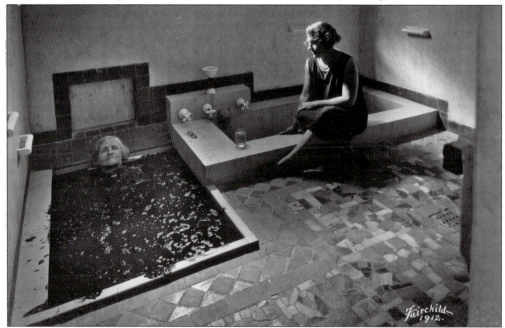

INTERIOR OF LADIES MUD BATH HOUSE. The Murrieta Fire Department responded to many calls from the hot springs over the years, twice to extract overweight women who were stuck in mud baths. The harder the firemen pulled, the deeper the mud suctioned the women into the tubs. It was a relief to all when the rescues ended successfully.

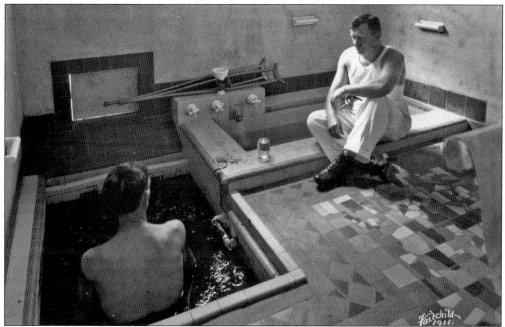

INTERIOR OF MEN'S MUD BATH HOUSE. Employees harvested mud from the tule marshes and chopped it into squares with machetes like meat cleavers. They carried it by truck to the Mud Bath House and carried it to the tubs in wheelbarrows. A continuous flow of hot mineral water helped guests to relax, and it eased their pain. Guests raved about the curative powers of the mud baths.

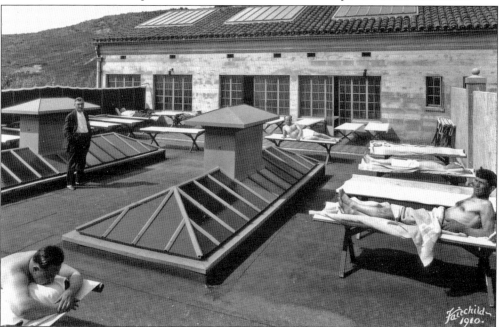

SUNBATHING. After a relaxing soak in the mineral water and mud baths, sunbathing on the roof of the gymnasium was a welcome getaway. A canvas partition separated women from the men. The men's side overlooked the swimming pool. Pilots from Hemet Ryan Field sometimes cut their engines and flew stealthily over the sundecks to see if they could sneak a peek at a bathing beauty.

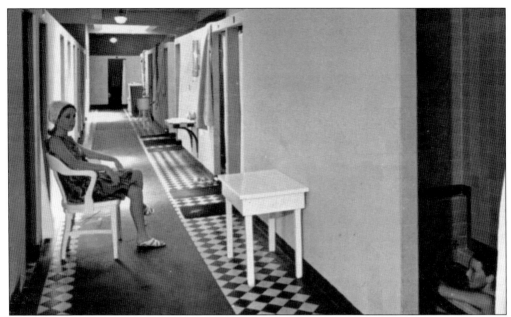

INTERIOR OF LADIES' MINERAL BATH. The Mineral Bath House featured a series of small rooms with sunken tubs and floor-to-ceiling tile. The tubs were 4 feet deep and 5 feet long, with steps for getting in and out. After a guest relaxed in a mineral water bath, he or she retired to a dry heated room furnished with cots for additional relaxation. Massages were also available.

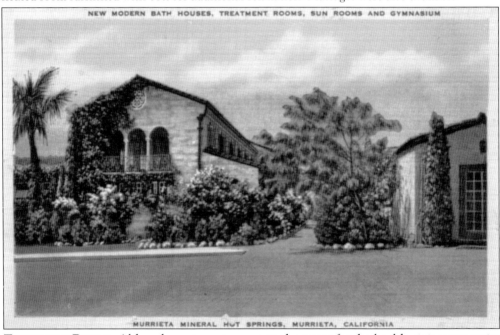

TREATMENT ROOMS. Although most guests came to the resort for the health-giving properties of the mud, mineral water, sunshine, and wholesome food, there was always a doctor on staff at the springs. One of the first physicians was a Dr. Mudd in the early 1900s, followed later by a Dr. Demeron in the 1940s and 1950s, and then a Dr. Harbeck in the 1960s. Sometimes the Guenthers drove guests to Elsinore for medical treatments.

BIG SPRING, SILOAM, OR BEAUTY SPRINGS. Guests used long-handled dippers to get water, and then they would drink from paper cups provided by the resort. The small alcoves held containers of salt to flavor the water, like salting a hard-boiled egg. Often guests filled jugs and bottles to take water home.

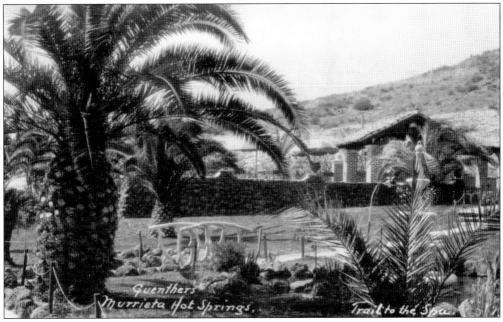

TRAIL TO THE SPA. The Guenthers used lava rocks from the Santa Rosa Plateau to construct interesting walls and other architectural features at the resort. They also covered handrails with cement to resemble logs, creating a rustic air. The smell of sulfur permeated the area, reminding guests of the natural and healthy environment.

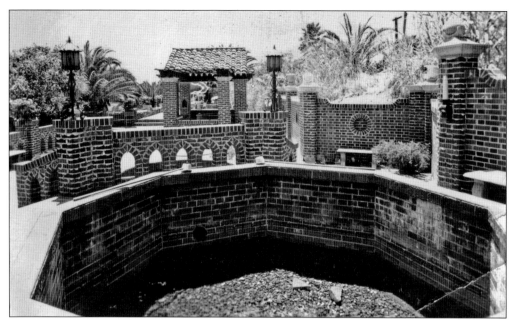

BIG SPRING. This area was bricked and tiled in 1932, with a floating reservoir constructed from the first swimming pool. This reservoir held hot mineral water for the baths. The water level changed constantly. This area was called Siloam Spring in early years of the resort. Much of the artistic brickwork is still standing.

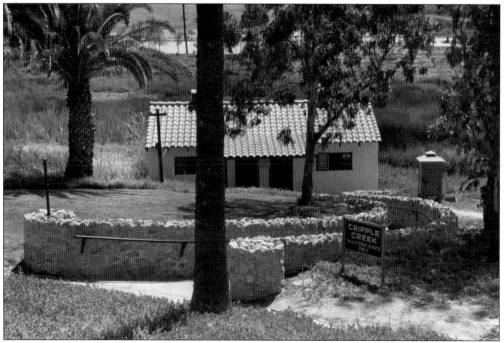

CRIPPLE CREEK. This site, where blankets were used for shade in the early 1900s, as shown on page 27, was later modernized. Bars were constructed over the water to prevent guests from soaking more than just their feet and legs in the hot water. Even with a warning against bathing in the water, occasionally the staff rescued foolish guests who got stuck between the bars in the hot water.

FOUNTAIN AT THE SWIMMING POOL. The musical flow and artistic beauty of this serene fountain contributed with the other water features to provide tropical relief from the sometimes relentless heat of the inland region. Lush vegetation and attractive landscaping lured guests into the retreat away from the hustle and bustle of city life. A koi pond surrounded the fountain.

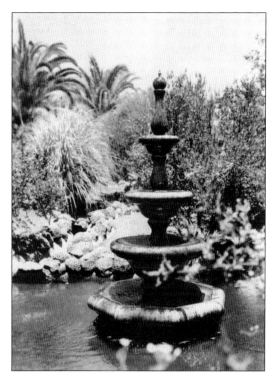

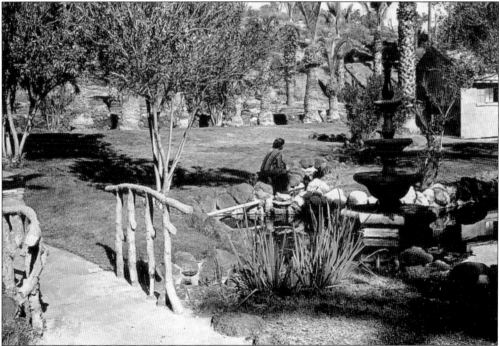

ANOTHER VIEW OF THE FOUNTAIN. This shows the bridge over the creek flowing with natural spring water and the pathway to Kidney Springs and Cripple Creek. The rails on the bridge were covered with concrete to resemble logs and to give a rustic appearance. This photograph shows a guest relaxing near the fountain.

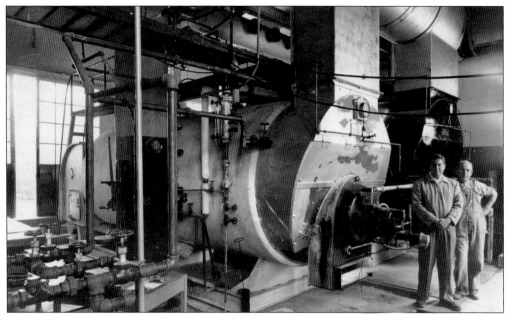

BUD GUENTHER IN BOILER ROOM. An unidentified employee stood with Bud (left) in the boiler room, which supplied heat for guest rooms and for the laundry room. The boilers converted water into steam. Boilers were constructed strong enough to resist bursting from high pressures inside. The boiler room was manned 24 hours a day. Bertha Randall operated the laundry room, which also served as the central office for housekeeping, for many years.

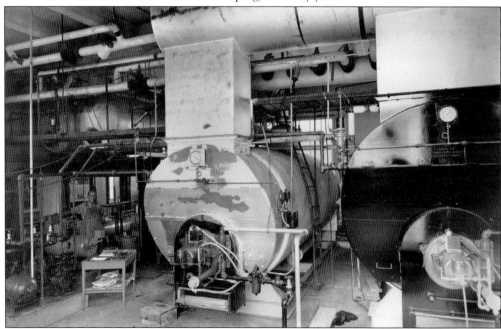

BOILER ROOM MACHINERY. Filters separated impurities from water entering high pressure boilers to prevent corrosion, which would eventually weaken the metal boilers or would cause scale to build up inside. A build-up of scale reduced the transfer of heat and eventually led to overheating of the boilers. Gauges monitored pressure inside the boilers to prevent bursting.

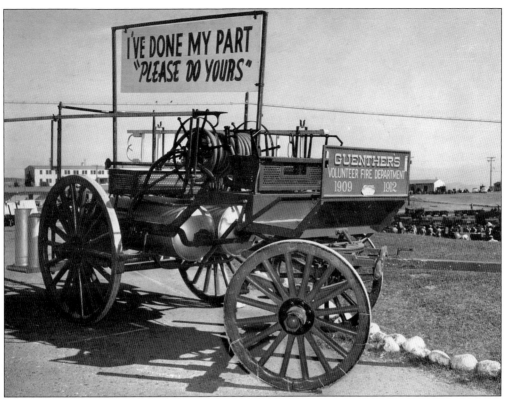

OLD FIRE ENGINE. This horse-drawn fire engine served Guenther's Murrieta Hot Springs' Volunteer Fire Department from 1909 to 1912. The resort was so far from any other towns, it had to be self-sufficient. Fortunately, its services were never required. This photograph was taken during one of the annual Murrieta Firemen's Barbecues that started in 1948.

TOO OLD TO FIGHT FIRES. The engine originally belonged to the Los Angeles Fire Department. The Guenther family donated it to the State of California for the Los Angeles Pueblo Project in the 1960s, and it returned to the Plaza Fire House, where it had been stationed between 1891 and 1896.

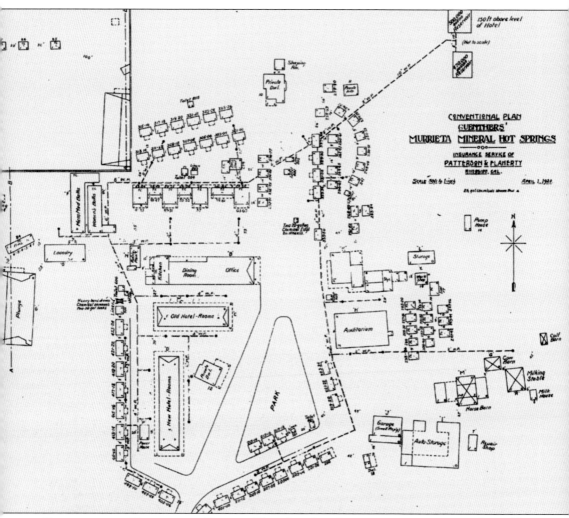

Conventional Plan of the Resort. This plan, done by an insurance company, showed how the resort was laid out in April 1, 1920. The lower right side of the drawing showed the location of the horse barn, cow barn, milking stables, and milk house. On the left side of the drawing were the covered plunge, the laundry (which was replaced with the Mineral Bath House), and the gymnasium. Several buildings have been razed and some have been replaced, but this diagram is a good reference for understanding where some of the old buildings pictured in this book were located and how the resort property was utilized during the era it was drawn.

Three

WHAT THEY DID FOR FUN

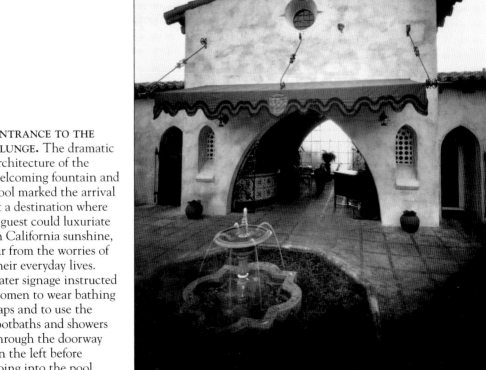

ENTRANCE TO THE PLUNGE. The dramatic architecture of the welcoming fountain and pool marked the arrival at a destination where a guest could luxuriate in California sunshine, far from the worries of their everyday lives. Later signage instructed women to wear bathing caps and to use the footbaths and showers through the doorway on the left before going into the pool.

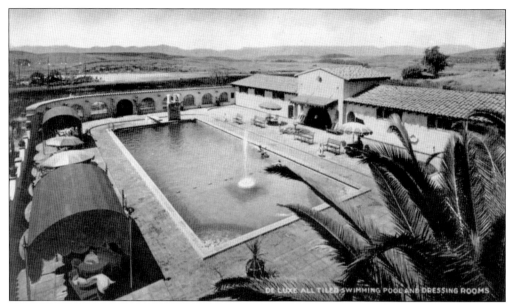

DE LUXE SWIMMING POOL. The imprint on a postcard from the 1940s advertised, "Extensive grounds, beautifully landscaped for the enjoyment of guests at California's greatest health resort." Ida Lorraine sent a postcard from the springs to her workplace in Los Angeles on May 11, 1956: "Am getting better and stronger every day. It won't be long now." The card advertised the excellent cuisine of the springs.

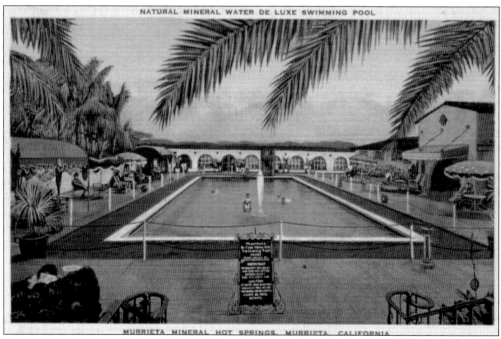

OPEN-AIR SWIMMING POOL. This was a big improvement from the days when Juan Murrieta's wife, Adele, and their children bathed in a wooden tub filled with boiling water from the springs. They boiled eggs in the sulfuric water while they bathed and ate them with their picnic lunches.

TOWER. An unidentified friend of Newell McCracken posed in an old-fashioned bathing suit near the tower. The architectural feature was well remembered by guests and staff who swam in the pool. Malcolm and David Barnett choreographed a game of throwing a ball from the top of the tower and swimming to a mushroom-shaped tile fountain at the other end of the pool. (VBV.)

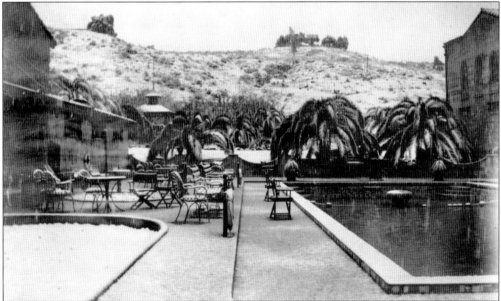

SNOW AT THE POOL. Snow came to the valley in 1949 and again in 1957. This image from 1949 captures the serenity and calm of the moment. During times when guests couldn't lounge outdoors, they could amuse themselves by playing card games, shooting pool, writing postcards, reading, drinking at the bar, or socializing. There was no lack of things to do at the springs, even in inclement weather.

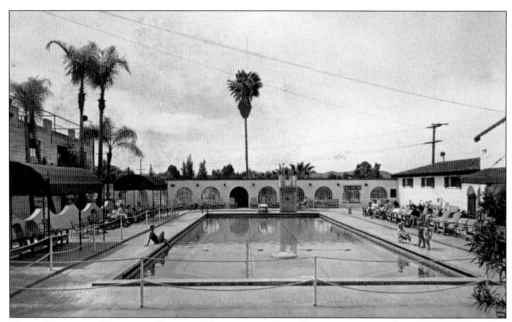

TILED POOL AND DRESSING ROOMS. The tower and mushroom mentioned on the previous page are shown here at opposite ends of the pool. A leap from the tower diving board could take an airborne boy halfway across the pool. This pool was filled with fresh water, not mineral water, and was not heated. After massage or mud baths, men sunned themselves on the roof above the men's bathhouse on the left.

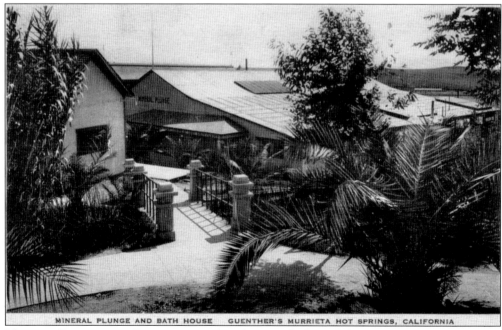

MINERAL PLUNGE AND BATHHOUSE. This photograph showed the pathway between the two buildings. Up until about 1930, swimming pools were called plunges. The warm mineral water in the pool gave comfortable and therapeutic soaking, especially soothing for arthritic and rheumatic discomforts.

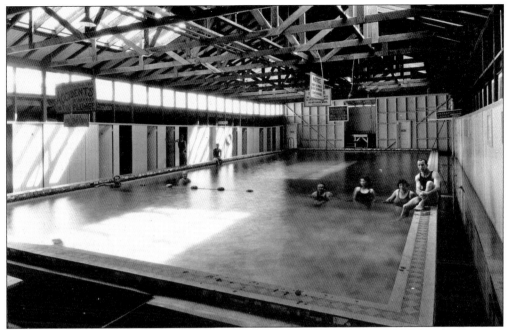

INDOOR PLUNGE. This photograph by Edward Noble Fairchild showed male and female swimmers in the Great Plunge. A sign on the right wall said, "Do not expectorate in the pool," and a spittoon sat in the foreground to accommodate anyone inclined to do so. The building was removed in 1929 when the pool was renovated, allowing poolside sunbathing.

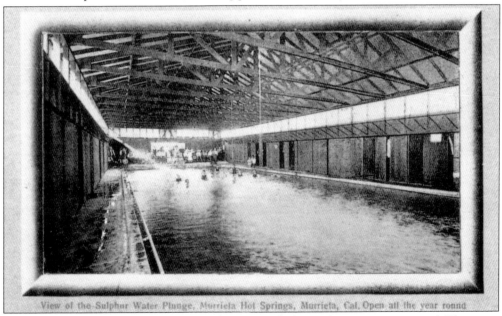

SULFUR WATER PLUNGE. According to this postcard, the pool was open year-round. The resort advertised, "At Murrieta all of Nature's remedies are present, together with the healing waters of the springs." Another postcard said people came to the sulfur water because of its miraculous and curative powers. The cover on the pool was reportedly made of corrugated iron. It was removed in 1929, and the pool was reconstructed.

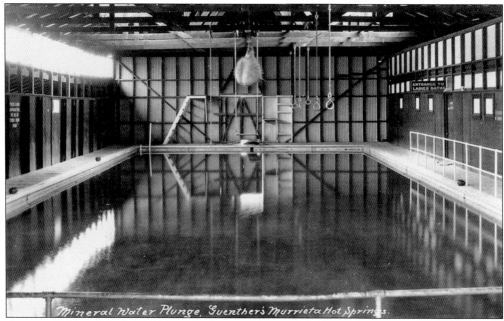

GYMNASTIC RINGS IN INDOOR POOL. This very early photograph of the plunge showed gymnastic rings suspended from the ceiling. The Guenthers were athletic. At the 1902 Turnverein Germanic Society picnic in Los Angeles, Hugo won first place in the shot put, high jump, and broad jump events. His sister Annie won first place in the egg race. Their brother, Rudy, was a gymnast and golfer. Rudy's daughter Murrieta performed synchronized swimming routines for guests.

BARE HILLS BEYOND. The view of the barren countryside in the background toward the tiny town of Temecula shows how remote the resort was from the rest of society. Murrieta was about four miles away, a walk some employees made daily from their homes during the Depression. The resort was like an oasis in a landscape of fields and undeveloped land.

THE TILE POOL. The tile in the pool came from the Dagoti Tile Company in Los Angeles. The back of a postcard advertised, "Horseback riding, tennis, and bicycling are among the many sports to be enjoyed at this popular resort. Moderate climate permits all-year outdoor recreation. There is always something to do at Murrieta Hot Springs."

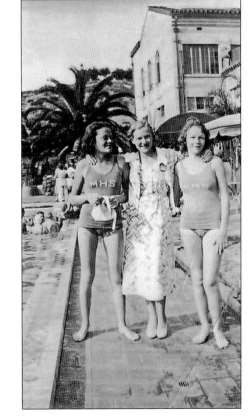

GIRLS AT THE POOL. The unidentified girl on the left sported a Murrieta Hot Springs bathing suit. This was the only pool in the valley, so the Guenthers generously allowed relatives of employees to swim for a nominal fee. During the 1940s and 1950s, the charge was 35¢. A wading pool was available for little tykes. (VBV.)

THROWING QUOITS. The game was played in an open court. Similar to throwing horseshoes, the quoits (rings of rope or flattened metal) were thrown to encircle upright pegs or hooks. The game was popular in New York state and other Northern states. In this picture, men have abandoned their suit coats for freer arm movement and, perhaps, a better chance at winning.

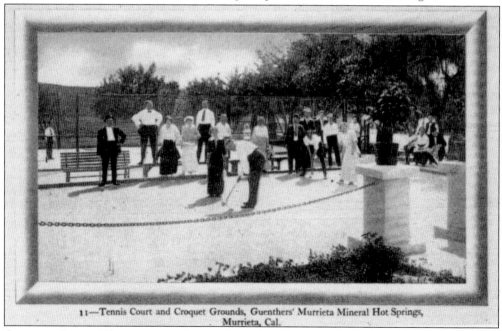

11—Tennis Court and Croquet Grounds, Guenthers' Murrieta Mineral Hot Springs, Murrieta, Cal.

CROQUET COURT. The resort was advertised as a place for rest and quiet but also for its recreation: "Don't think that things are wanting in the amusement line, for there is almost everything imaginable to please." Badminton and croquet were favorite pastimes.

PLAYING CROQUET. The men in this photograph by Waldo Henry Dingman Sr. played croquet, sometimes called lawn tennis, in their shirtsleeves in front of the tennis court. According to a brochure, "There are so many things to amuse that it would be impossible to enumerate them." Notice their formal dress for the sport.

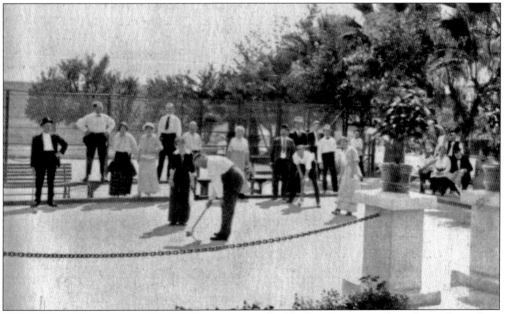

ANOTHER CROQUET GAME, 1914. A man is coached by his partner, perhaps his wife, on how hard to hit the ball to get it through the two links in front of him. A resort brochure advertised, "A beautiful lawn tennis court, croquet grounds, acrobatic bars, dumb-bells, boxing gloves, and punching bags for outdoor sport are kept in good order."

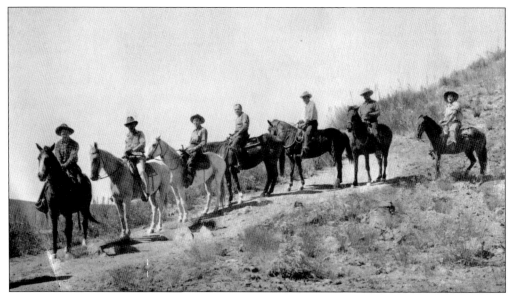

OUT FOR A RIDE. Seven urban cowboys rode a trail behind the Hot Springs. From left to right, they were Tom Hackenberg, Mack Stone, "Woody," Art Brunelle, Bud Guenther (riding a horse named Red), Gib Miller, and identified. Gib Miller, a retired cowboy who spent many years in the saddle on old-fashioned cattle drives, ran the stables at the springs and directed the trail rides.

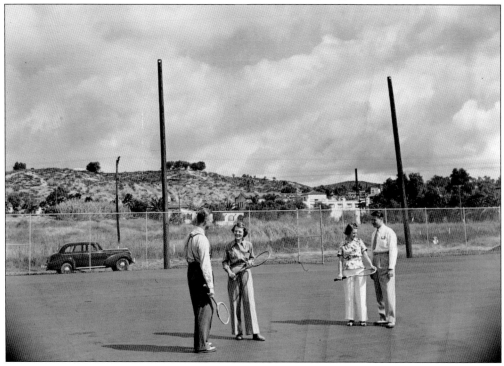

A TENNIS GAME. An unidentified man on the left discussed technique with Murrieta Bergey Maher (Fritz Guenther's granddaughter), while Evelyn Guenther Reekie and Bud Guenther strategized on the right. A handsome 1939 sedan waited in the background. Later owners opened a tennis school at the resort that has become a private tennis club.

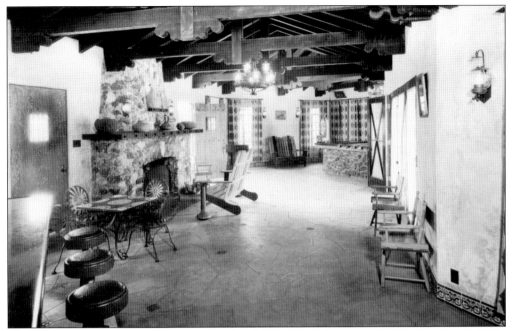

AMUSEMENT AUDITORIUM. This building, which is now a bookstore, was constructed in the 1920s and used as the clubhouse for the miniature golf course. It was a coffee shop in the late 1950s and a recreation room in the 1960s. The resort newsletter, the *Guenther's Gazette*, said teenagers played the jukebox, mothers enjoyed the women's clubhouse, and children played on the playground.

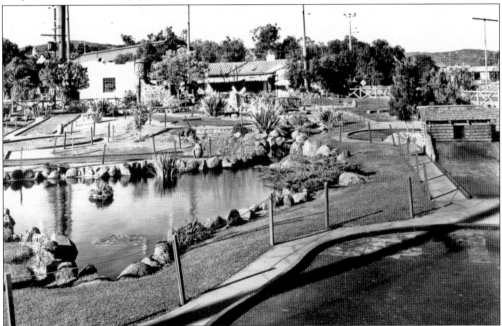

MINIATURE GOLF COURSE. The springs advertised "a beautiful and sporty, deluxe 18-hole miniature golf course." This Fairchild photograph shows the pond and proud landscaping along the course in front of the clubhouse in the background. The clubhouse was designed with a rustic charm inside and outside. The outer courtyard featured an open fireplace.

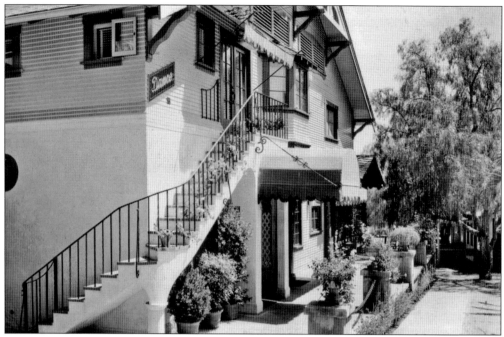

DANCE AUDITORIUM. The building, also called Memorial Hall, was constructed in 1912. It was dedicated to the memory of Fritz Guenther, who had recently died, for his visionary development of the resort. Fritz's son, Rudy, his wife, Florence, and their daughters, Murrieta and Dorothy Ann, stayed in the apartment upstairs. The lower left part of the building is now a hospitality room, the center is an auditorium, and the former bar to the right is now a coffeehouse.

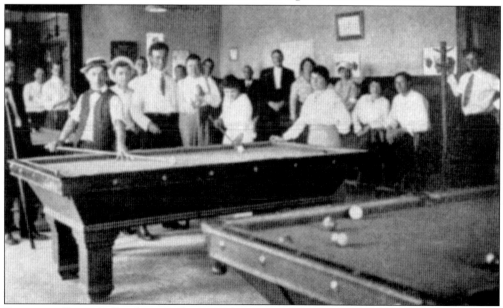

SHOOTING POOL. Billiards amused men and women after dark and on days when it was too hot or rainy to be outside. Similar games of American snooker were played on the green felt tables at the springs. Markers on the wire above the billiard table were paperless scorekeepers, moved by reaching up with a pool cue.

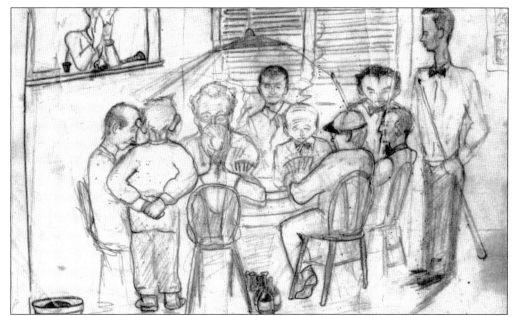

THE CARD ROOM. Up to 200 people played cards at a time, while a waiting line formed outside. The most popular was a rummy game called "Pan," short for Panguingue. When the springs were raided in the 1970s, the players said they only gambled with beans in the card room, but they often settled with cash in the parking lot after the game. The cartoon was drawn by Bill Christian, a waiter. (SEB.)

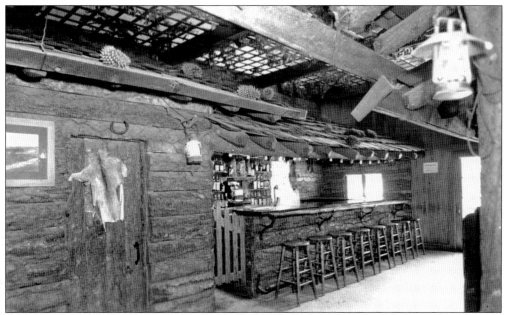

FORTY-NINERS ROOM. This frontier bar, where "thirst vanished," was constructed in 1933 at the end of Prohibition, bringing into the open the sale of alcohol that was previously hidden in a speakeasy under the dining hall. The bar shown in this Dingman photograph was also known as the Log Cabin Tavern. A Western theme was provided by lanterns, tanned hides, and logs still covered with rough bark.

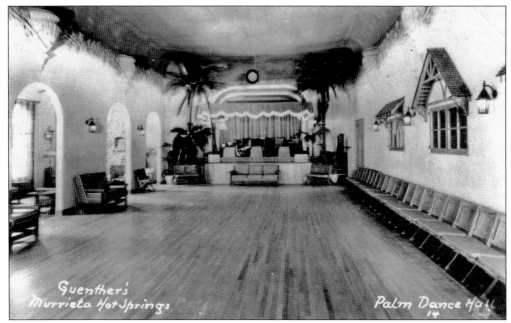

PALM DANCE HALL. Guenther's Murrieta Hot Springs provided top-billing musicians to entertain guests on holidays and weekends, including trumpeter Manny Klein, clarinetist Mickey Katz, and other musicians. When professional musicians were not at the resort, the song went on, with talented waiters and lifeguards doubling as instrumentalists. Even Bud Guenther joined in when needed.

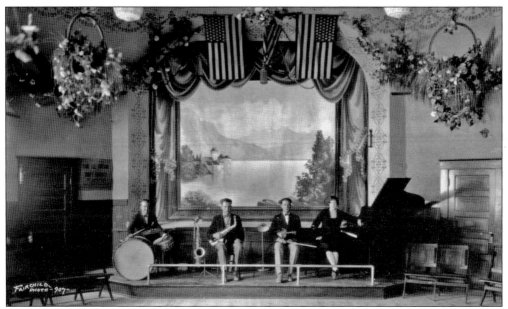

AUDITORIUM STAGE. Four unidentified musicians showed their instruments on the stage in the formal dance hall decorated with flags and flowers. Arthur Murray dance teachers gave lessons in swing, mambo, and cha cha. Ray Bezanson, a waiter, often wrote the music, as well as playing the piano, bass, or drums. Fritz Guenther was an accomplished zither player, and his son, Rudy, played the mandolin. The Memorial Hall reflected a Tyrolean theme.

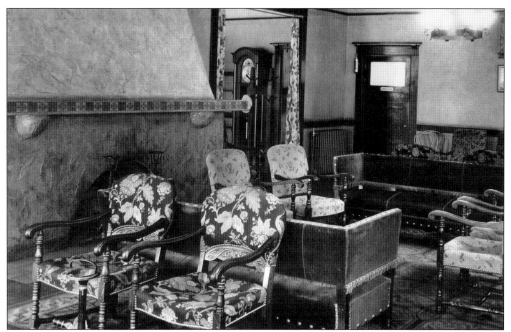

SITTING ROOM. The Sitting Room, with brightly patterned upholstery and drapes, served as a hotel lobby outside the office door. The formal room featured decorative tin ceilings and was cooled by ceiling fans. Guests waited in the Sitting Room to enter the dining room. This room was later used for a television lounge.

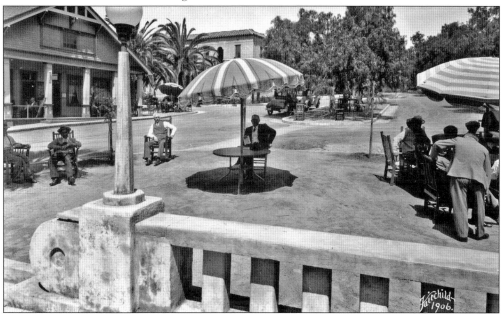

LOUNGING BY THE BRIDGE. One man sat in the sunshine, while others found shade in this Fairchild photograph that was reproduced on postcards. Sitting near the bridge and watching people was a favorite pastime. On some evenings, a lifeguard and activities director named Tommy Tyndall, also known as the "Pied Piper," would serenade guests near the bridge with accordion music. The bridge was removed in 1962 to construct the new office.

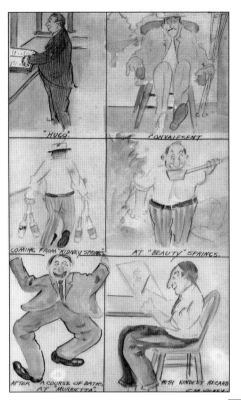

HOT SPRINGS CARTOONS. Thanks to C. M. Hickey, shown in the bottom right, we have a humorous and condensed history of resort activities. Hickey packed meaning into each image, infused with his insight into the workings of the resort and the character of the people. For example, the frame showing the man coming from Kidney Springs depicted a guest who has refilled his bottles with spring water. (JGC.)

ONE-ARMED BANDIT. Slot machines like this one from the hot springs were found in cafés, gasoline stations, and other businesses throughout the valley. Often they were hidden by a curtain. Law enforcement personnel turned a blind eye to gambling, as they did to alcohol sales during Prohibition. In the late 1940s, many of the area slot machines were taken to a landfill and destroyed.

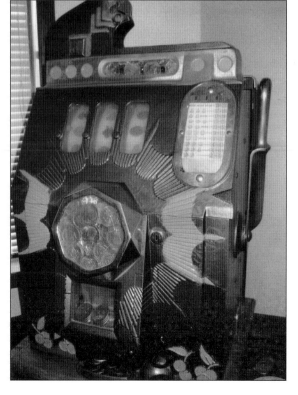

MORE CARTOONS. More vignettes of life at the springs are depicted in these whimsical cartoons by Hickey. Guests always looked forward to receiving mail, which was distributed by Hugo Guenther at mail call. The dancers were peppy after taking baths. Sunny Jim was the legendary bartender at the speakeasy. (JGC.)

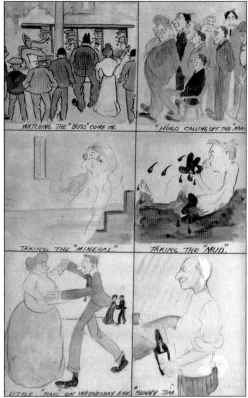

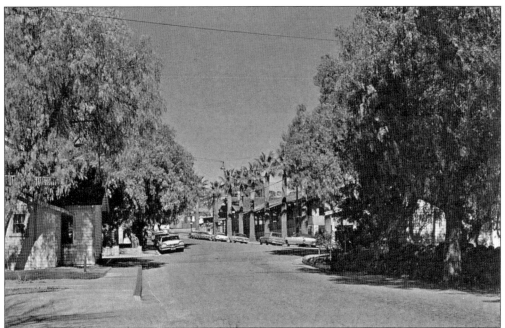

GATEWAY TO THE SPRINGS. This is what an arriving guest would have seen in the early 1960s. The 400 Row cottages were on the left and the new administration building was ahead, to the right. The pepper trees were full and parking spots were scarce.

BATHHOUSE TILE. Beautifully patterned painted tile was placed throughout the resort. The Dagoti Tile Company in Los Angeles imported tile from Holland and Italy for use in fountains, pools, and countertops at the resort. The Italian tile in the entry to the men's bathhouse was bright blue, yellow, black, and white.

GYMNASIUM. This area above the men's bathhouse (below) and overlooking the swimming pool was the guest workout room for decades. It housed equipment for weight training, rowing, tumbling, juggling, and boxing. The gymnasium was converted to a movie theater in the 1950s, where classic 35-mm films of all genres were shown to guests on Wednesday and Sunday evenings.

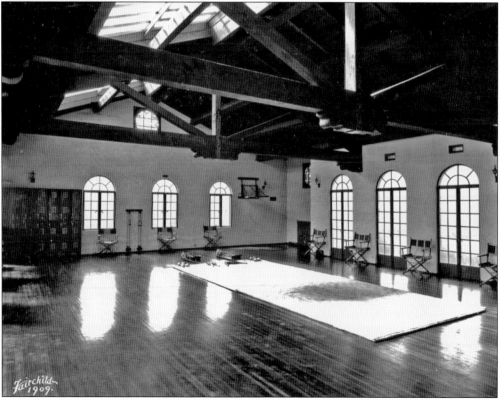

ARENA. Big-name professional boxers, who came from Los Angeles and the East Coast, used this spartan wood building in a grove of trees on the hill for their training. In the 1950s, when the boxers trained elsewhere, an English pool table was installed for family snooker games. During off-hours, employees also frequently enjoyed shooting snooker there.

BOXERS. Throughout the 1930s, the springs had a steady stream of boxers who trained at regular intervals. The actual bouts were primarily staged in the Los Angeles Olympic Auditorium and Hollywood Legion Stadium. The fighters were generally lightweight class to welterweight. Because of his bellowing voice, Hugo Guenther was asked to announce fights, but he declined. Hugo was considered a close friend to famed heavyweight boxer Jim Jeffries during those years.

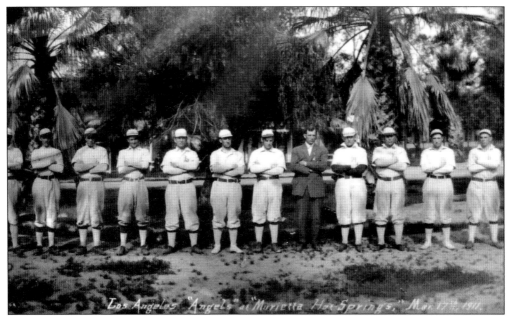

Los Angeles Angels at the Springs. Members of the Coast League baseball team, led by Frank "Cap" Dillon, trained at the springs in March 1911. They endured an unseasonably rainy spring training with hot mineral and mud baths, alcohol rubs, and massages. Hugo Guenther was at their beck and call and provided daily delivery of the *Los Angeles Times*, so they could read the pink pages of the sports section.

Guenther's Sign at Tennis Court. This solitary neon sign welcomed travelers to the hot springs. It stood at the edge of the tennis courts along Murrieta Hot Springs Road. Two or three additional signs advertising Guenther's Murrieta Hot Springs appeared on local roadsides along U.S. Highway 395 amid occasional Burma Shave signs.

ANNA BLOOM. Pictured here by the pool with Bud Guenther (left) was the self-titled "Queen of Murrieta Hot Springs," who was remembered as a wonderfully warm and generous person and a friend to all. Anna, a colorful character in her flowered print dresses, lived in "Room 1" of the Monterey Hotel for extended stays during the 1950s. She always kept candy aside for the Guenther children.

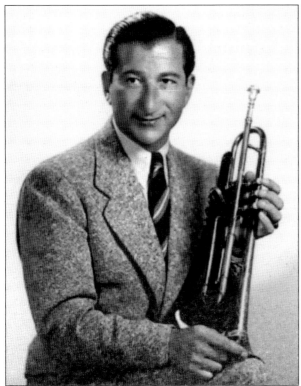

MANNY KLEIN. Klein was an accomplished musician and a great friend to Bud Guenther and his family. A talented and versatile trumpeter who backed some of the most notable orchestras and bands of the 1930s and beyond, Klein had range and precision that were reminiscent of many of the acknowledged musical "greats." On occasion, he performed on the Murrieta Hot Springs stage. He and his future wife met at the springs during the 1940s. (Courtesy of Klein Family.)

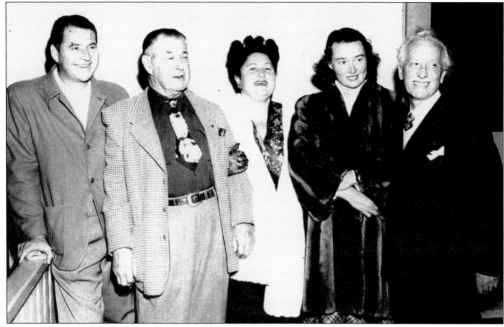

THE CARTERS AND THE GUENTHERS. Mark Carter, a longtime president of the City of Hope's board of directors, and his wife, Reva, were known as humanitarians of the first order. They are pictured here honoring Bud Guenther for his service to their organization. From left to right are Bud Guenther, Hugo Guenther, Reva Carter, Ellen Guenther, and Mark Carter.

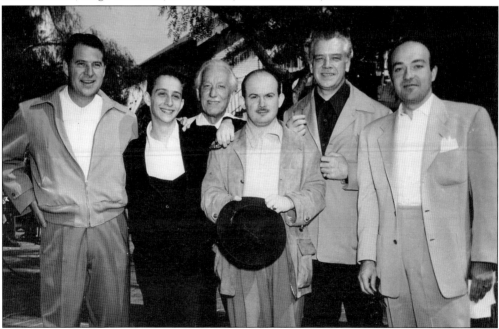

MICKEY KATZ AND OTHERS. From left to right, Bud Guenther, Joel Grey, Mark Carter, Mickey Katz, George Blake, and an unidentified man posed together at the springs. Mickey was a versatile Yiddish entertainer and musician, and his son Joel Grey became a renowned actor. George Blake worked as front office manager at the hot springs for over 40 years.

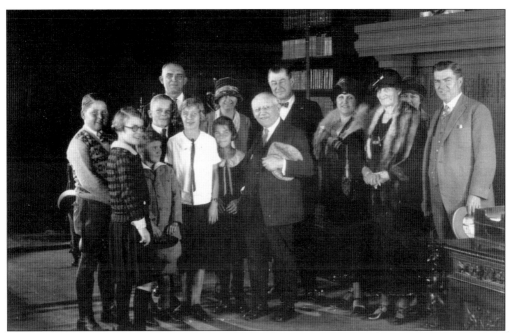

GUENTHERS WITH CARL LAEMMLE. "Uncle Carl" (center) was surrounded by friends and members of the Guenther family. Laemmle, a founder of Universal Pictures, was credited with giving Erich Von Stroheim his first direction job in 1919. Fritz and Hugo Guenther knew Laemmle from their association with the Shriners Al Malaikah Temple of Los Angeles. Also related to motion picture production, Fritz's son Rudy's business rented furniture to studios for film props.

JACK BENNY AND WIFE, MARY LIVINGSTONE. The humorist, humanitarian, and actor Jack Benny was a friend of Hugo Guenther's. He was one of the many entertainers who visited the springs during the 1920s through the 1950s. Marvin Curran remembers seeing Phil Silvers, of Sergeant Bilko fame, standing on a table entertaining a large crowd waiting to enter the Dance Hall.

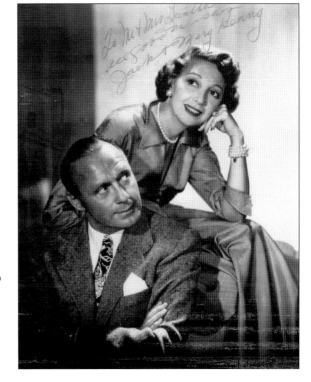

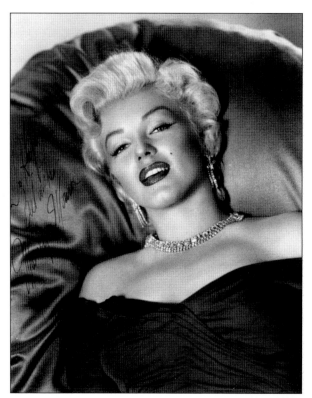

MARILYN MONROE. No one knows the circumstances surrounding this autographed photograph of Marilyn Monroe. Hugo never talked about it. After Hugo passed away, the family found the picture in his files. The occasional entertainers who came to the springs enjoyed comfortable anonymity during their stays.

MEL BLANC. Blanc, the man who gave the voices to all the famous Warner Brothers cartoon characters—Bugs Bunny, Sylvester the Cat, Porky Pig, Daffy Duck, and Speedy Gonzalez—delighted guests at the springs with his voice characterizations. Bud Guenther's children remember when he autographed copies of his record album covers. He was a person who made everyone feel special.

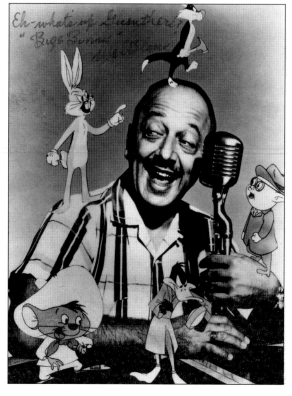

Four

FROM TENTS TO LUXURY HOTELS

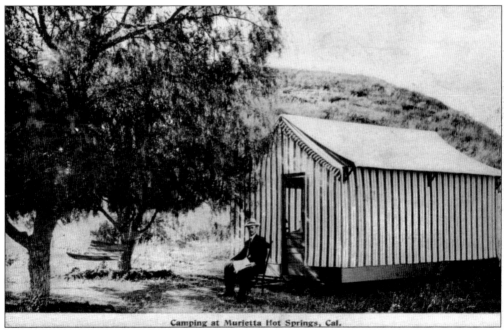

CAMPING AT "MURIETTA" HOT SPRINGS. This postcard, printed before the spelling of the name of the town was standardized, showed a camper sitting outside a tent at the springs. In 1877, the owner, C. B. Robinson, built a bathhouse and a 14-room hotel. This card, sent on January 27, 1908, cost 1¢ to send and was postmarked "Murrietta."

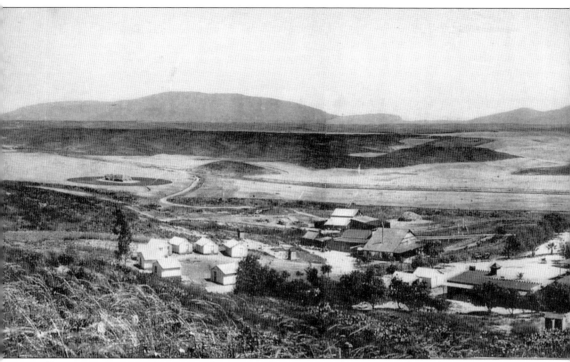

PANORAMA OF THE SPRINGS. The postcard imprint on the reverse side read, "Birds Eye View of Guenther's Murrieta Mineral Hot Springs, One of America's Most Popular Health and Recreation

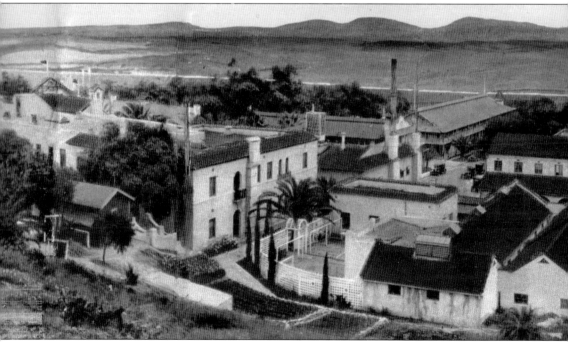

BUILDINGS AND TREES AT THE SPRINGS. When Fritz Guenther purchased the hot springs, the buildings constructed by Robinson 25 years before had deteriorated. Most of the land was used for farming and not for healing purposes, although an invalid would sometimes come to soak

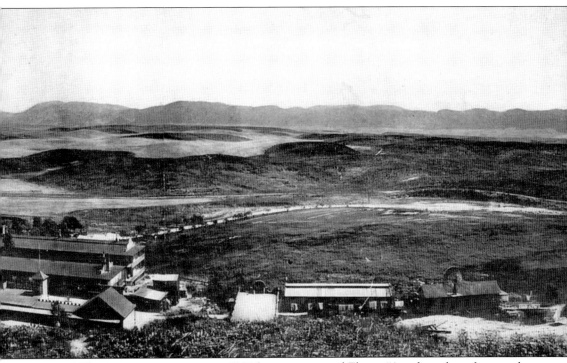

Resorts." The message was written in 1920 by a man named Elmer: "Am down here for a week. Had lumbago. It is 100 degrees every day and cool in the evenings. Was 110 degrees one day."

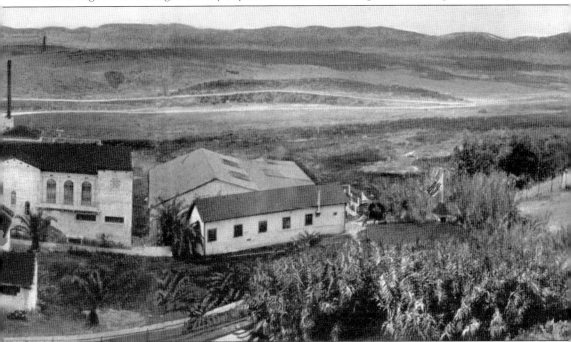

in the springs. The young pepper trees in the foreground are still growing, and the palms tower high above the Annex, which is called the Stone Lodge today.

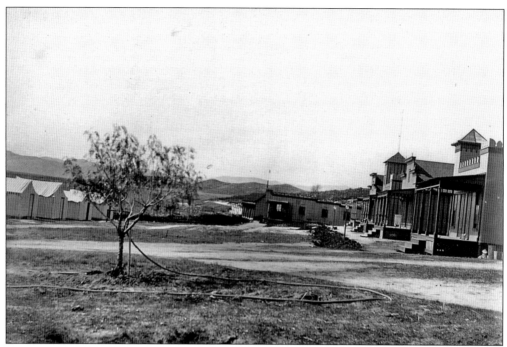

TENTS AND COTTAGES, 1903. This photograph by R. G. Fernald, a Temecula photographer, showed tents on the left, the bathhouse in the center, and cottages on the right. Rates were $10 a week for tents and $12 for cottages with toilet facilities. The dining room was later built where the tents were.

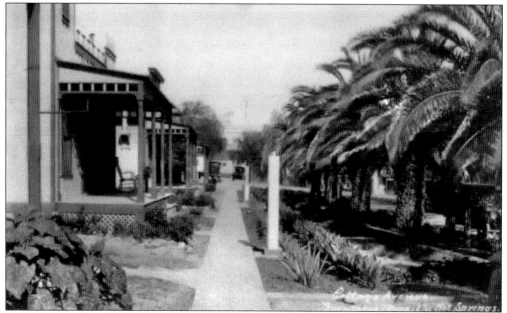

ANOTHER VIEW OF THE COTTAGES, 1911. The structures of Cottage Row, built in 1903, were moved across from the Dance Hall in 1925. The Annex Hotel building, later called Stone Lodge, was built at their original location. Guests arriving at the springs enjoyed the unhurried, peaceful atmosphere offered, in contrast to the city bustle from where they had come.

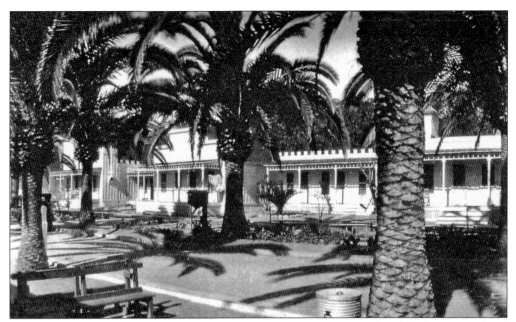

COTTAGE ROW, 1929. The gingerbread facades were eventually replaced with more updated Spanish architecture. While Fritz Guenther's son, Hugo, ran the day-to-day resort operations, it was his son Rudy who designed the pleasing architectural features. This picture shows how much the palm trees had grown since the 1911 photograph was taken. Weekly guest rates included room, board, baths, and "ordinary attention."

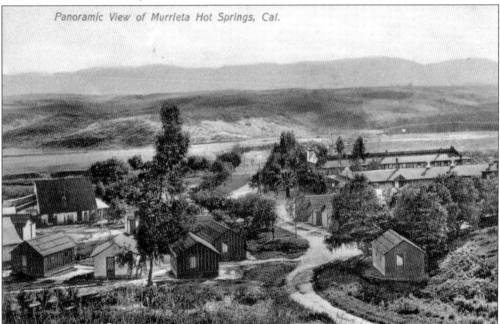

ORIGINAL HOTEL BUILDING. The original hotel, later called the Farmhouse, was the large building at the left. Constructed in 1887, it was razed in the late 1920s. The cabins in the foreground eventually became lodging for employees of the springs. The road through the resort was unpaved at the time the photograph was taken.

THE FARMHOUSE. By 1893, when Riverside County was formed from a large section of San Diego County, the springs were not used as a resort. Farmers used the house when they tilled and harvested the dry farmland. Fritz Guenther bought 200 acres of ranchland for $12,000 and then gradually added 300 more acres, using the 20 acres around the hot springs as the resort center.

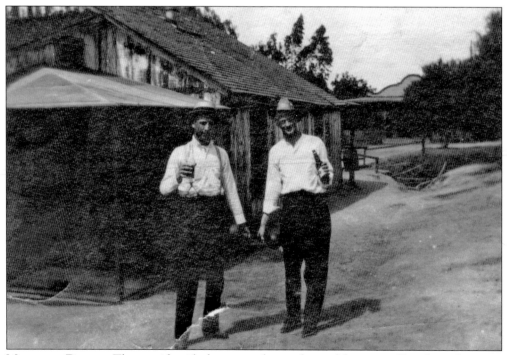

MEN WITH DRINKS. These unidentified men standing in front of the original hotel may be guests or employees taking a break in this photograph taken in August 1909. Were they tipsy? Were they drinking mineral water or something stronger? Several postcards indicated the springs cured alcoholism, but libations flowed freely there, even during Prohibition.

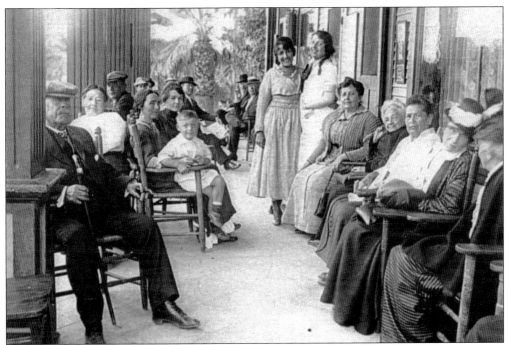

WAITING FOR THE DINNER BELL. Guests, who were required to dress for dinner, waited for the dinner bell. Meals, included with room charges, were served in two separate sittings for lunch and dinner. The same waiter served a family for every meal and received a tip at the last meal of the family's stay. Fritz, Hugo, Bud, and their families enjoyed eating meals at their family table in the guest dining room.

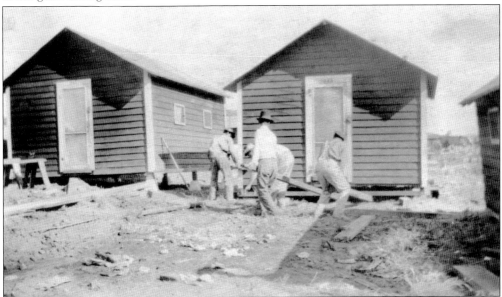

MOVING CABINS, 1920. Workmen moved the cabins to an area near the garage to use as employee housing. Eventually Bud Guenther donated some of the cabins to families in French Valley. In 1939, a worker taking care of hogs earned $90 a month, a waiter made about $100 in pay plus tips, a head office clerk made $175, and the head bookkeeper made $210 a month.

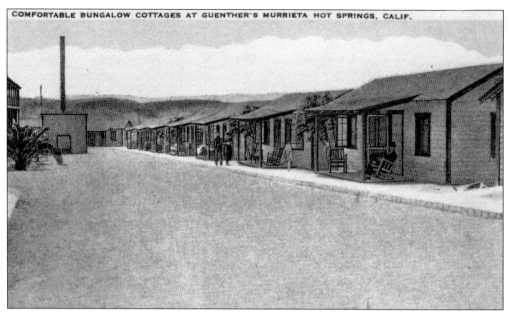

THE "400 ROW." This row of comfortable bungalow cottages faced the California and Monterey Hotels. The tall chimney behind was part of the boiler plant that supplied hot water and steam heat to buildings throughout the resort. The bungalows each had a flush toilet and a sink. Guests soaked away their aches and pains in the nearby mineral baths.

COTTAGE ROW, C. 1950. These cottages originally stood beside the main office and were later replaced by the Annex, the main hotel, in 1925. They were moved across from Memorial Hall to be used as employee accommodations and were renamed Whiskey Row. By 1962, Whiskey Row was torn down to make way for the modern 800 Row Bungalows.

THE "300 ROW." This Fairchild photograph, later printed on postcards, depicted the "modern" bungalows behind the Annex Hotel. An amusing note from a postcard read, "Dear Flossie, I will let you know I am here and having a good time. Jeanette has not wanted for company or a good time, although she is the only girl here."

OFFICE STAFF, 1952. George Blake, office manager, stood with Naomi Larson and Annette Bidart, second and third from the left respectively, and three unidentified employees on February 23, 1952, during the Mahnia Silverberg Auxiliary Concert. Silverberg started the auxiliary at the City of Hope Hospital. Notice the varied reading material available at the desk, including a Hebrew newspaper, at the far left. The springs received the *Los Angeles Times* daily.

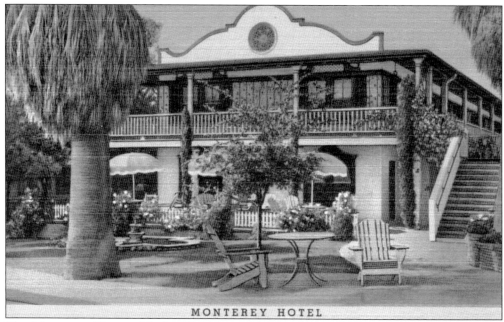

THE MONTEREY HOTEL. The hotel was completed in 1904 with running water and a toilet for each room. In 1970, one guest recalled that he had been coming to the spa since 1915. His original transportation from Boyle Heights was pulled by a double team of horses. During the 1970s, he and his wife came every six weeks for a Thursday through Sunday stay.

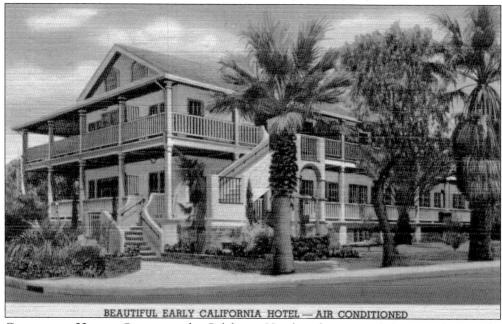

CALIFORNIA HOTEL. Guests saw the California Hotel as they entered the grounds near the office at Guenthers Murrieta Hot Springs. It was built in 1908 to keep up with the demand of the ever-increasing popularity of the hot springs. The rooms were equipped with steam heat and possessed all of the modern conveniences of a first-class resort. In 1916, rates for the California Hotel were $26 to $28 per week, per couple.

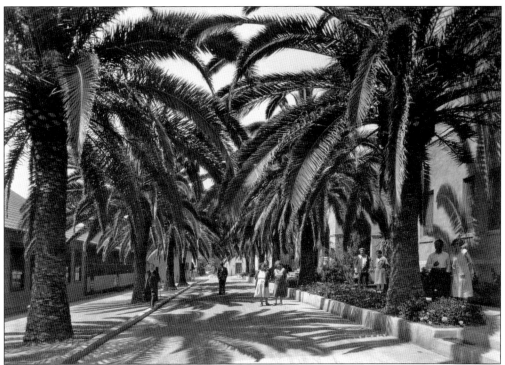

PALM ROW. This image of the front of the New Annex hotel was a favorite, reproduced on many postcards. The street and sidewalk connected the bath houses and pool to the main thoroughfare at the front office, dining room, and assembly hall. Some of the earliest photographs show the same palms when they were just a foot tall.

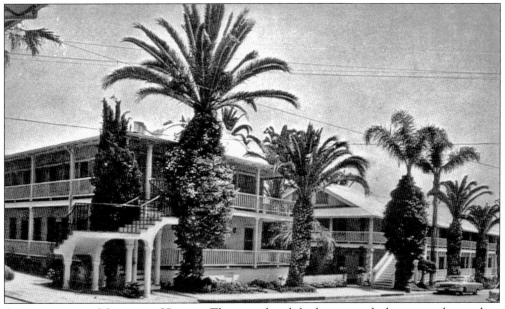

CALIFORNIA AND MONTEREY HOTELS. These two hotels look very much the same today as when they were first built. Today they are used as women's dormitories for Calvary Bible College. The bathrooms have been remodeled and upgraded for the convenience of the students.

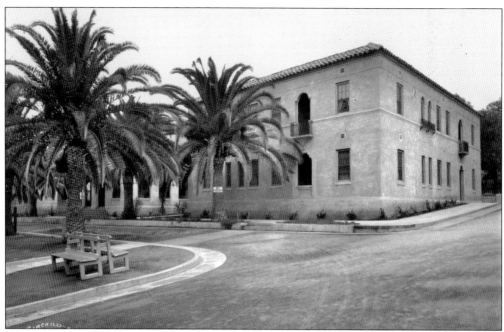

ANNEX HOTEL. With the gas lamp and horse-and-buggy era disappearing, the Annex Hotel was the first major attempt to bring the hot springs into the 20th century. Construction was completed March 26, 1926. Cottage Row was moved to make way for the construction of this new hotel, which was modern for its day.

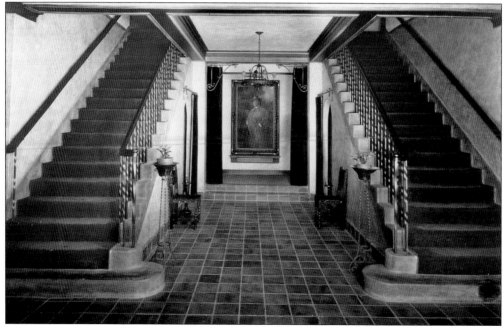

INTERIOR OF ANNEX. Guests entering the Annex Hotel were greeted by the life-size oil portrait of Fritz Guenther, the founder of the Murrieta Hot Springs Resort. The Annex was advertised as a "fireproof hotel, in the Spanish Style Architecture." The oil painting hangs in the home of one of Fritz's great-grandchildren today.

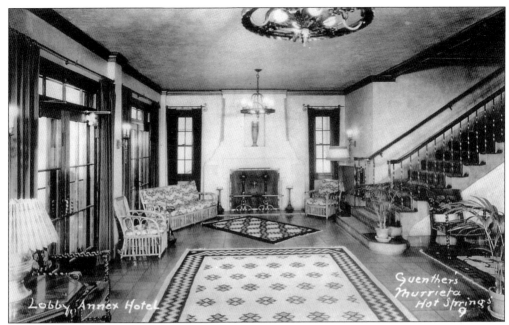

ANNEX HOTEL LOBBY. In 1963, according to the printed "Rates and Accommodations," the Modified American Plan, which included breakfast and dinner, cost $27.50 to $29.50 weekly, with double occupancy. The Annex Hotel had private toilets and showers for the convenience of guests.

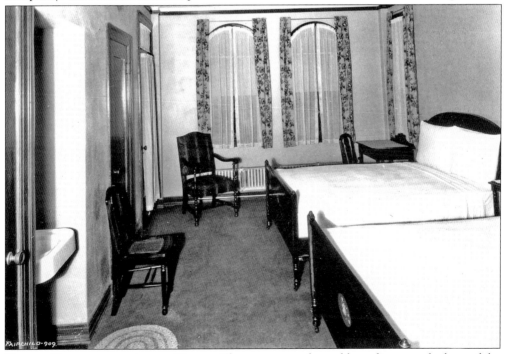

TYPICAL ROOM IN THE ANNEX HOTEL. The rooms were heated by radiators at the base of the windows, supplied with steam generated at the boiler plant. Today these rooms look much the same and are used for retreat and guest lodging. One door led into a closet and the other into a private bathroom.

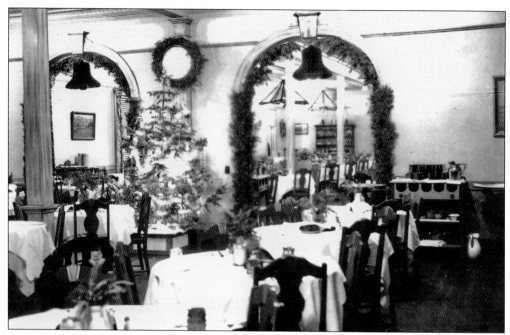

CHRISTMAS IN THE DINING ROOM. Even though most of the guests were Jewish, they enjoyed the Christmas tree and other seasonal decorations in the dining room (above). Bud's children, Fred, Judy, Carl, and Tony, fondly remember distributing souvenir-type gifts to guests, such as engraved key chains, combs, or wallets.

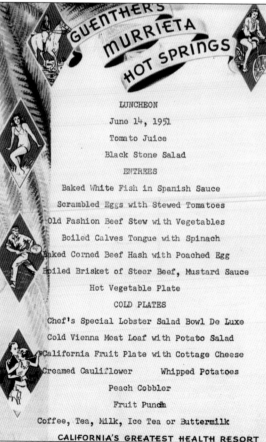

LUNCHEON MENU, JUNE 14, 1951. The clang of a bell announced each of the maître d's two sittings. Waiters always hoped their diners would arrive and decide on their menu choices quickly, so the waiter could get his order placed first. It was always a challenge for the waiters to get through the first sitting, clean up, and then set up for the second sitting in just one hour.

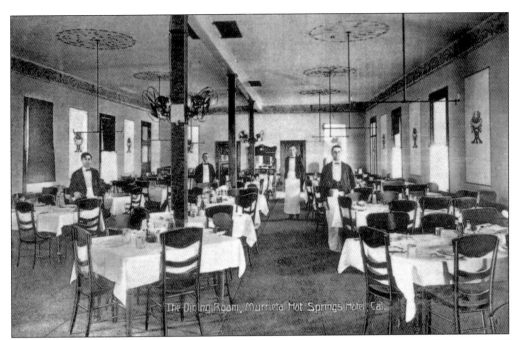

DINING ROOM. The dining room, built in 1904, was illuminated with acetylene gas lights. Guests passed through the office to enter the spacious and cheery dining room, where waiters were ready to serve them. The kitchen was in the rear of the building, behind the dining room.

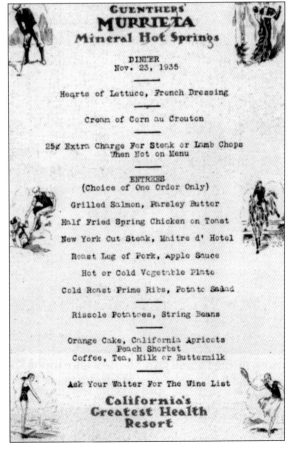

DINNER MENU, NOVEMBER 23, 1935. This is a typical menu with selections for the evening meal. The resort was known for its excellent food. Many of the guests would stop at the sundries counter to purchase Alka-Seltzer or another brand of antacid after overeating. Then a well-satisfied diner would often take a stroll down Murrieta Hot Springs Road.

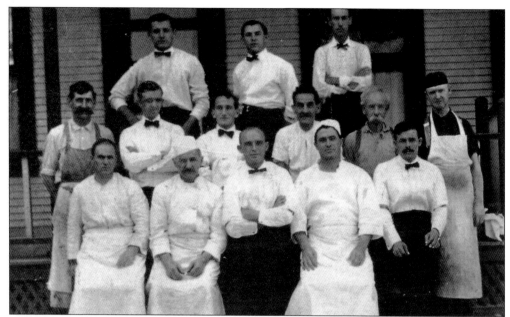

COOKS AND WAITERS. A gentleman, who had been coming to the resort since 1915, remembered family-style dining with milk by the pitcher and butter by the pound. Meat was served three times a day. Rates, including a series of 21 baths, ranged from $7 to $9 per week.

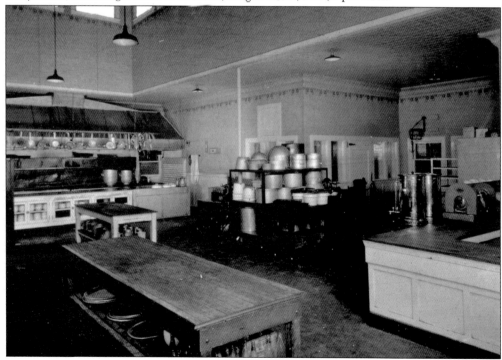

INSIDE THE KITCHEN. This was the kitchen as seen from the swinging doors coming from the dining room. The table to the right was where iced teas, coffee, and other beverages were prepared, and at the far right is where salads and hors d'oeuvres were prepared. The meat locker was in the back center, with the large commercial stove to the left. The bakery was out of view to the left.

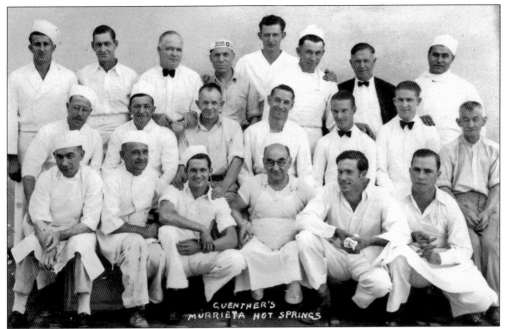

COOKS AND WAITERS, 1934. From left to right are (first row) Teddy Banack, Henry Simon, Paul Allen, Fred Haneberg, Jack McCrackin, and Howard Haskell; (second row) Alex Coomber, Emile Girard, John Dolney, Jerry Young, Chester Barnett, Warren Kimball, and Jack Rageth; (third row) Karl Reinhart, Tom Keys, Leonard Smith, Sam Arakehin, William Pratt, Mike Mance, Walter Beebe, and Mike Katangian.

COOKS, WAITERS, BAKERS, AND CHEFS. Bud Guenther, owner of the resort, was seated in front, flanked by kitchen employees. The head chef supervised the cooks, butchers, bakers, and kitchen help. The maitre d' assigned tables to the waiters and busboys. Aromas of freshly baked bread wafting into the dining room from the bakery whetted the appetites of the guests.

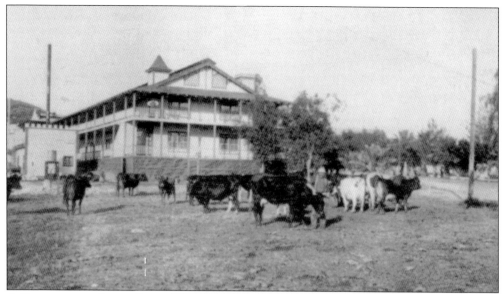

A PART OF THE GREAT DAIRY HERD. The springs' herd of purebred Holstein cows won prizes at shows and fairs for their quality of milk. Mary Von Moos, who worked at the dairy for 18 years during the 1940s and 1950s, said the Guenther cows were given numbers, not names. Cow No. 23 won most of the ribbons, cups, and awards. The dairy bottled milk in 1/3-quart bottles and 5-gallon cans.

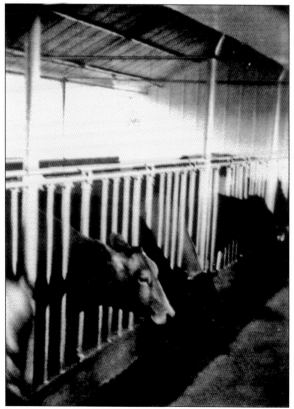

THE DAIRY. The springs was noted for their fine dairy products. Guests found sweet butter, cream for their coffee, and cold pitchers of fresh, whole milk on their dining tables. Surge milking machines whirred at 3:00 a.m. and again in the afternoon, milking the prize-winning, thoroughbred Holsteins. Unpasteurized milk went through the separator, dividing the cream from the milk. Pigs and calves lapped up skim milk unused by the kitchen.

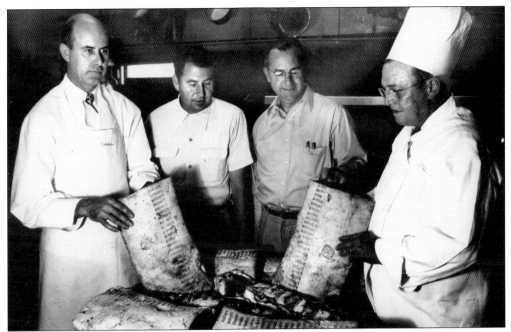

MEAT. In many ways, the springs was self-sufficient, supplying meat, dairy, and produce for its dining room. Hogs, chickens, and cattle were raised at the springs in the early days. In this photograph, beef purchased elsewhere was inspected by, from left to right, butcher Ed Decker, owner Bud Guenther, purchasing agent Ed Record, and an unidentified head chef.

PORK AT THE SPRINGS. Hogs raised at the springs supplied succulent pork for the tables and served as living garbage disposals. The springs did not keep kosher kitchens for Jewish clientele, some of whom enjoyed the opportunity to eat pork while visiting. Judy Guenther remembers seeing a diner pull the waiter close enough to read the menu. "I want this kind of beef," the guest said, pointing to a pork dish.

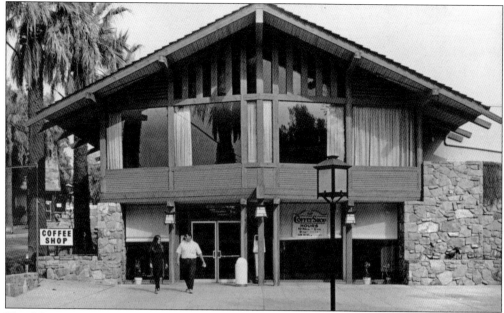

THE NEW OFFICE, 1969. This view showed the coffee shop on the lower level of the new administration building, constructed in 1962 for $1 million. The upstairs entrance on the other side was also at ground level because of the hillside slope. The building housed the resort office, bar, dining room, and kitchen and is still in use. The couple in front had just arrived by private plane from Palm Springs.

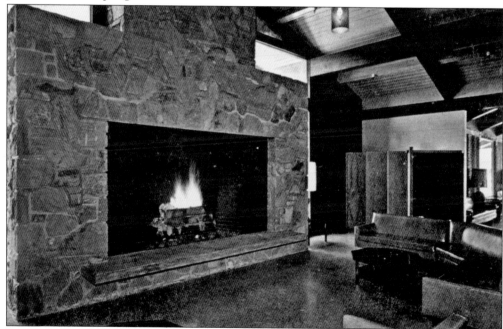

FIREPLACE. This stone fireplace gave a cordial reception to visitors in the administration building. It warmed guests waiting to enter the dining room. There was a bar near the fireplace for before dinner drinks. The fireplace still warms the room, now decorated with reproductions of several of the vintage photographs featured in this book.

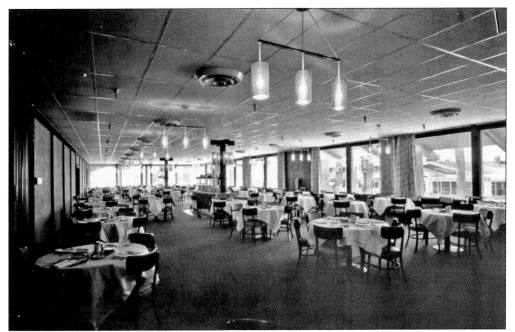

NEW DINING ROOM. The spacious dining room, designed to utilize natural light, gave easy access to the kitchen at the left. The style of chairs shows the contemporary ranch theme incorporated throughout the building. The dining room is still in use for conferences and community events. Over 200 people attend the Murrieta Prayer Breakfast there each May.

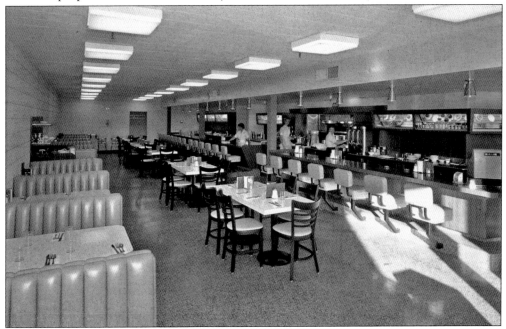

INSIDE THE COFFEE SHOP. This is how the coffee shop would have looked on the day the couple pictured on page 88 entered it. In a less formal setting with Formica tabletops, the coffee shop offered short order meals all day long, in contrast to dining upstairs on linen tablecloths with two or three options at lunch and dinnertime.

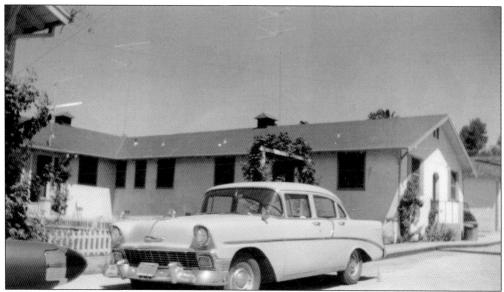

EMPLOYEE QUARTERS. A 1956 Chevrolet and a television antenna demonstrated the good life enjoyed by employees of the springs. Although many of the staff were professionals or were residents of nearby Murrieta, some, who were down on their luck, came by bus to find jobs.

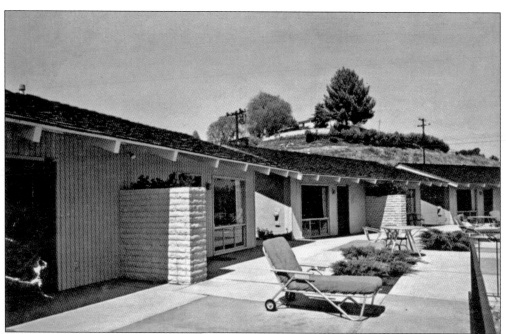

NEW DELUXE BUNGALOWS. In the 1960s, the bungalows featured free television and air-conditioning. People still came for relaxation away from the cities. A postcard sent in 1938 to a Miss Kaplan in Chicago read, "We are broadcasting from Murrieta, 100 miles from Los Angeles, just so that husband of mine can take a fancy mineral bath and massage. Getting so damn swell, ordinary baths aren't good enough for him."

"THE 800 ROW." A 1961 Rambler and 1962 Corvair fill the first two parking spaces in a familiar location. Ten years before, Hugo Guenther received a letter from Herman Marquand: "I didn't know English, but you gave me a job, a place to stay, a place to dine, money, comfort, and my bread and butter. I have worked for many people, but there is not another man as good as you."

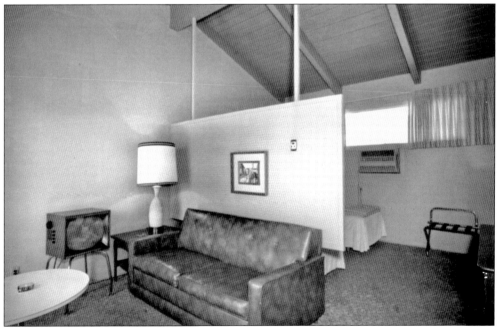

A TYPICAL ROOM. A resort room offered all the comforts needed for time away, including air-conditioning, FM music, television, a refrigerator, picture windows, and a hot mineral tub in each unit. When the old Cottage Row was demolished in 1961, Hugo Guenther said, "It served us faithfully for nearly sixty years and was battered to splinters in sixty minutes."

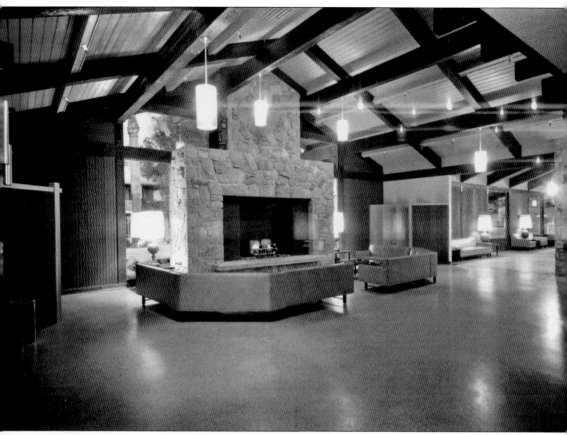

CHANGE IN THE AIR. Remodeling in the late 1960s and early 1970s evidenced the changes taking place in the management of the Murrieta Hot Springs. After 68 years, the Guenther family decided to sell the institution that was also their family home. Taxes were burdensome, people expected more anonymity; everything was different from the resort hotel and spa they started in 1902. It was time for a change. The Administration Building was constructed in a contemporary ranch style in 1962. This anteroom to the dining room was formerly a bar. The room was remodeled to reflect the modern informality shown in the photograph. Today an enlargement of our cover photograph is part of the decor.

Five
THE VISIONARY GUENTHERS

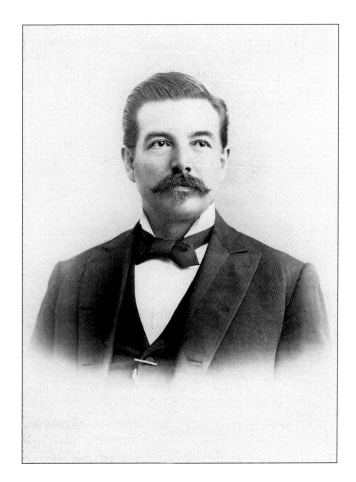

FRITZ GUENTHER. Fritz was born in Magdeburg, Germany (Prussia), on Christmas Day, 1848. To avoid conscription into the Franco-Prussian War, he traveled with his younger brother, Bill, to New York in 1870. After Bill left for the West Coast, Fritz lived in Chicago, Virginia City, Sacramento, and Los Angeles. After owning a succession of three saloons in Los Angeles, he sold out to buy land in the Murrieta Valley.

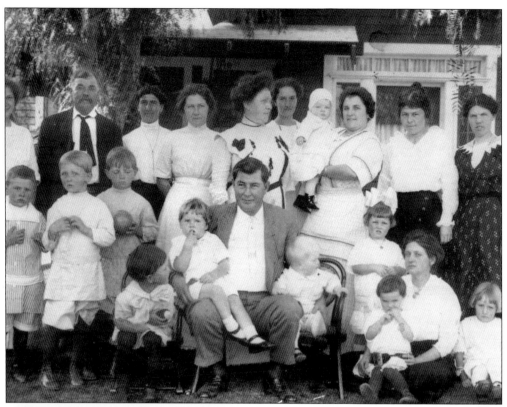

GUENTHERS AND STAFF, C. 1914. Congenial household staff and employees posed with the Guenther family in front of Fritz Guenther's former home. After Fritz's death in 1912, sons Hugo and Rudy took over management and development of the springs. They continued the traditions of hospitality set in place by Fritz.

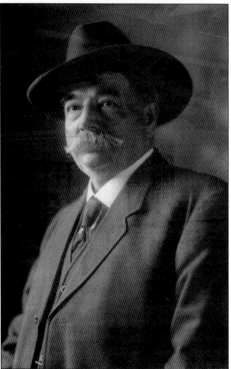

FRITZ GUENTHER. Although Fritz spoke very little English, he was successful because of the way he adapted himself to the opportunities available. A cabinetmaker by trade, he built pool and billiard tables for the Brunswick-Baulke Collender Company. Later he shored up wood in the mines of the Comstock Lode and finally was a saloonkeeper before he and his sons sold their holdings to become innkeepers.

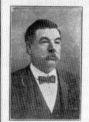

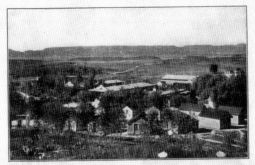

ADVERTISEMENT FOR MINERAL WATERS. Claims for healing benefits were plentiful in years prior to overseeing by the Federal Drug Administration. Patent medicines making similar promises of curative powers were sold by the bottleful. This advertising was based on fact, since the drinking water at the springs actually aided digestion, while bathing in it relaxed and soothed sore muscles. (JGC.)

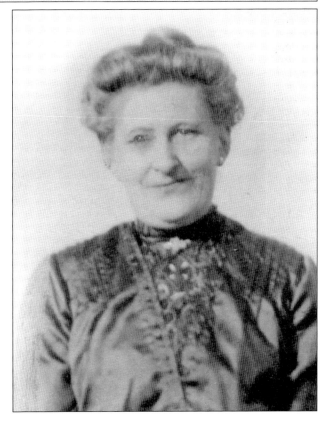

FRITZ'S WIDOW. Louise Ludeman Guenther and her twin sister, Amanda, came to Los Angeles from the Schleswig-Holstein region of Germany in 1875, when they were 16 years old. Louise met Hugo while she worked as a cook and housekeeper for some of his friends. After they married in 1883, they kept a home near MacArthur Park. After Fritz died in 1912, Louise moved to the springs. She died in 1939. (CBH.)

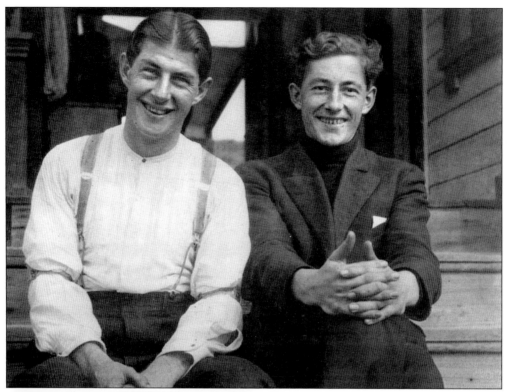

Brothers Hugo and Rudy Guenther. This photograph showed Hugo (left) and Rudy (right) as they looked when they were ready to embark on a partnership that would change the shape of the Murrieta Valley. Hugo's talent was utilized in organizing day-to-day operations as an innkeeper, while Rudy's artistic gifts were used to design the many architectural and landscape features at the springs.

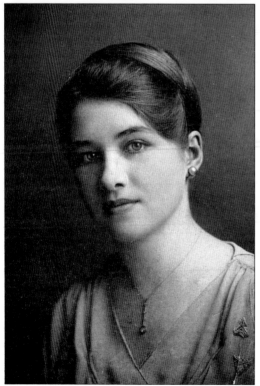

Florence. Rudy Guenther married Florence Anna Reis. They met when she vacationed at the springs in the 1920s. Daughters Murrieta and Dorothy Ann were born to them. They maintained an apartment at the springs and a home in Beverly Hills. Hugo and Rudy's sister Annie married Charles L. Bergey, whom she met at the springs. They moved to Arcadia and had a son, Jack, and a daughter, Murrieta. (MGL.)

HUGO. Born in 1883, it fell on his shoulders to carry on the enduring legacy begun by the "Old Man," Fritz. Although partnered with his younger brother, Rudy, during the formative years, Hugo was the mainstay whose leadership gave the springs its vitality. A leader in community affairs, youth groups, trade associations, and benevolent causes, he was an exceedingly generous and well-liked man.

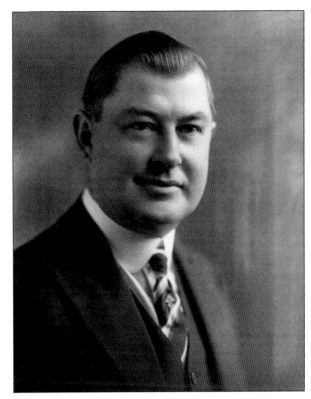

RUDY. Born in 1885, Rudy, a man of many talents, started with Hugo on day-to-day operations but soon devoted himself to supervising the design and construction of buildings and landscape on the property. His architectural style is still reflected today in the structures and layout that remain. He lived in Los Angeles for much of his life. He was an avid golfer, a California historian, and a charming and outgoing man.

ROSE MARKWALDER GUENTHER. Rose came from a prominent Swiss family in Los Angeles. She met Hugo while her family vacationed at the springs. They were married in 1909. Their children, Evie and Bud, were born at the Murrieta Hot Springs. Her strict parentage gave her a seriousness with an appearance of aloofness. She was a strong woman of the era. She worked hard during the formative years of the resort. (JGC.)

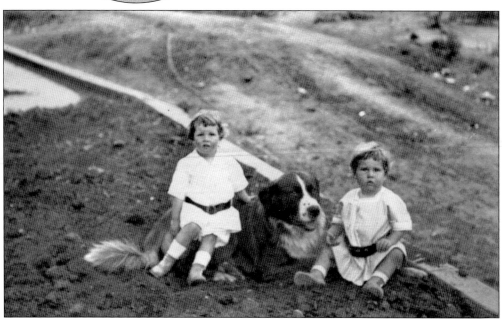

EVELYN AND BUD GUENTHER. With a year-and-a-half age difference between them, Evie and Bud were the center of attention while growing up at the springs. Like all family members, they worked at many different resort jobs during their youth. They said it was a wonderful experience to know so many people from various backgrounds while growing up and that it was like having a second family.

BABY BUD WITH THE MAILBAG. Hugo picked up the mail every day from the Murrieta Depot. Guests looked forward to mail call, when Hugo called out names in his deep voice. Periodicals including the *Los Angeles Times*, *Herald Examiner*, *San Diego Union*, *Riverside Enterprise*, *B'nai Brith*, and the *Voice* came regularly, for sale in the resort office. The mailbag is still owned by the Guenther family.

ANNIE GUENTHER. Annie, the third child of Fritz and Louise Guenther, was born in Los Angeles in 1887. Following high school, she met Charles L. Bergey at the springs. They married and lived in Arcadia. They had a son, Jack, and a daughter, Murrieta. Annie served as a member of the board of directors at the springs until she died in 1969. She was known as a remarkably warm and caring person. (CBH.)

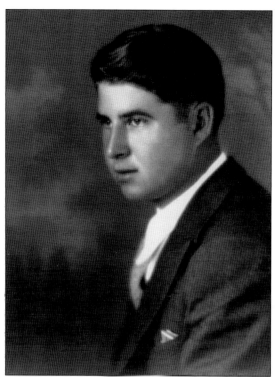

BUD GUENTHER. Frederick Hugo Guenther was known as "Bud" since his birth in 1911. After graduating from Harvard Military School in Los Angeles, he attended Riverside City College. He served as a lieutenant in the State Guard, now known as the National Guard, during World War II. Bud became an assistant manager to Hugo when Rudy's business in Los Angeles required more attention.

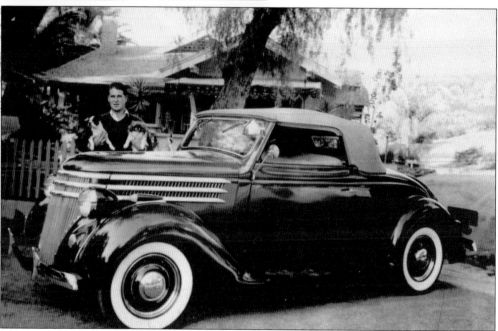

BUD AND HIS 1936 FORD. Bud stood next to his used 1936 Ford drop head coupe in front of the family home a year or two before his marriage. He was an avid horseback rider, swimmer, and hunter, and was active in the Masons, Shriners, and Scottish Rites. Earl Gilman's sister Wanda, from Gilman Hot Springs, introduced Bud to his future wife, Ellen Nixon, while they all vacationed in Hawaii.

1947 Cadillac. Hugo (left) and Bud Guenther posed next to Hugo's 1947 Cadillac with the Annex Hotel, the main hotel, in the background. They had just squeezed through the war years and were about to enjoy a second era of prosperity. During the war, they were relatively self-sufficient with a dairy herd and pig farm and other supplies purchased during weekly truck runs into Los Angeles.

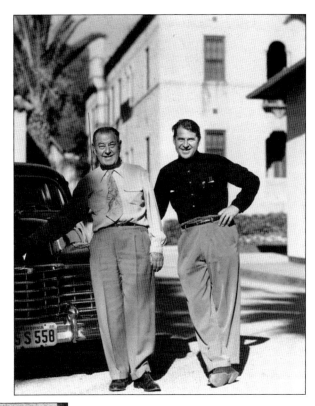

Fred Guenther Jr. This photograph shows Fred beside the monument honoring his great-grandfather Fritz Guenther, who died in 1912. After graduating from Denver University's Hotel and Restaurant Management program, Fred returned to the springs in 1964 with his family of three to assist his father, Bud. He implemented many new ideas to attract a younger clientele to the resort.

BUD AND ELLEN'S WEDDING PICTURE. The January 15, 1939, edition of the *Los Angeles Times* carried an announcement of the impending marriage of Bud Guenther and Ellen Nixon. Ellen's sister Clara Nixon Livingstone gave a cocktail party for them at her home in San Marino on April 9 and hosted the marriage ceremony three days later. The couple honeymooned in Laguna Beach. Ellen had attended Pomona College after graduating from Bishop's School in La Jolla.

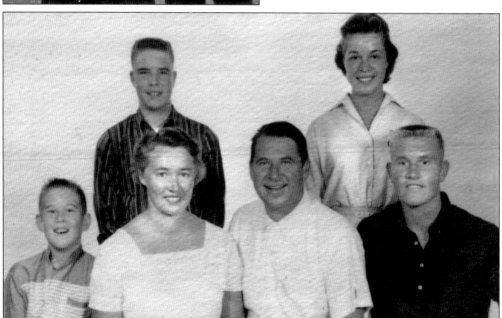

GUENTHER FAMILY, 1958. From left to right are Tony, Carl, Ellen, Bud, Judy, and Fred in Oceanside, where Ellen kept a home away from the springs. They escaped to the beach house from the pressures of business and from the inland heat. Fred was about to go to college, Judy was graduating from high school, Carl was ready to start military school, and Tony was going to summer camp. (JGC.)

TONY GUENTHER BEHIND WHISKEY ROW. These rooms were formerly called Cottage Row before they were moved to make way for the main hotel, or Annex. Cottage Row was renamed Whiskey Row. Effie and Eddie Decker, employees of the resort, shot the photograph.

CARL AND JUDY GUENTHER. Like many students at the one-room Alamos country school, Carl and Judy rode the few miles barefoot and on horseback, a 30-minute ride from their home. Carl (left) rode Pinafore, and Judy rode Trinket, holding their dog, Taffy. They formed strong friendships with other students from the French Valley countryside. Students from the Alamos School meet for a reunion every year. (JGC.)

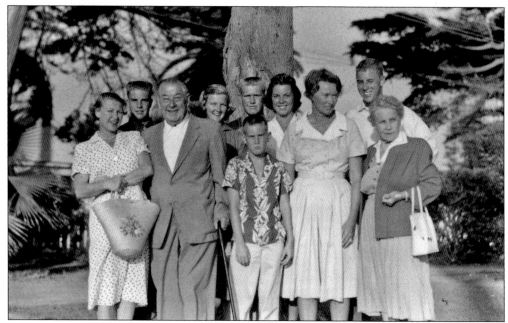

THE GUENTHER FAMILY, 1959. From left to right are Evelyn Guenther Reekie, Carl Guenther, Hugo Guenther, Eileen Reekie, Fred Guenther, Tony Guenther, Judy Guenther, Ellen Guenther, Keith Reekie, and Rose Guenther. Bud took the picture next to Hugo's house in Oceanside.

HUGO AND TONY GUENTHER. Hugo was a leader in the Riverside County Council of the Boy Scouts of America, earning the Silver Beaver Award. All three boys in the family entered Scouting: Fred was an Explorer Scout, Carl was a Boy Scout, and Tony was a Cub Scout. Hugo often paid fees for local boys to attend Scouting activities. Fred, Judy, and Carl also were involved in the 4-H Club.

Six

FROM TEAMSTERS TO POLARITY

NEW OWNERSHIP. "Miss Billy" Riley, shown on the right with an unidentified guest, managed hotel operations during the early 1970s. Irvin Kahn, an attorney and real estate developer who had visited the resort as a child in the 1930s, bought the 500-acre Murrieta Hot Springs in January 1970 for $1.35 million. A Beverly Hills firm master-planned the modernization and expansion of the facilities. (BR.)

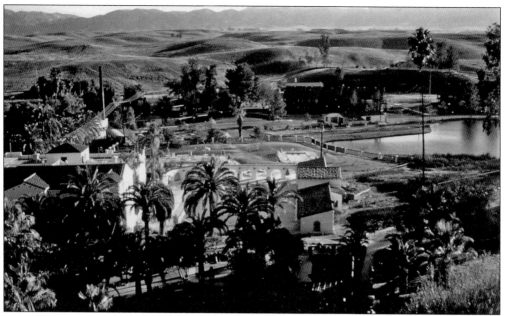

KAHN LAGOON. Before anything else began, renovation started with grading, leveling, and excavation of 1.4 million tons of soil. They developed a freshwater lake, creating a quiet and peaceful atmosphere, and built condominiums around it. The new owners spent millions of dollars on site improvements and spa development in the still-remote area surrounded by a rolling countryside.

MURRIETA PROGRAM INFORMATION CENTER. After Kahn added acreage to his original purchase, he made real estate available within the boundaries of this 1,000-acre paradise for the first time in 60 years. The former clubhouse served as the information center for the newly developed resort complex, the condominiums, and mobile home sites. Murrieta Hot Springs was advertised as a resort for all seasons.

RILEY AND GUEST. As manager, Riley dealt with everything from plumbing problems to personnel. She marketed the resort and spa to attract a younger crowd. She previously managed the Half Moon Inn in San Diego, also owned by Kahn, and was eager to work with him to develop the resort in the open countryside near Murrieta. (BR.)

KAHN AND RILEY. To raise $100 million to purchase and renovate the resort, Kahn secured funding from a variety of sources, including union money from the St. Louis Pipe Fitters Local No. 562, the Las Vegas Valley Bank of Nevada, the Great Western Mortgage Company of San Diego, and Morris Shenker, a St. Louis criminal lawyer. (BR.)

NEW BAR. Although the mineral baths were still used, and the facility was still considered a health spa, a newly remodeled lounge and bar, adjacent to the main lobby and outside the dining room, provided urban comforts. No cost was spared to ensure guests would enjoy their vacation time away from home. The hot springs was still a regular stop on the Greyhound bus route in 1970. (BR.)

DANCING. Dancing, a time-honored activity at the springs, continued into the 1970s. Kahn, seen here, danced at an event during "Gay 90's Week." Themes like this entertained guests at the resort and encouraged a feeling of community. Relaxation and fun, begun by the Guenthers, continued at the recreational spa. (BR.)

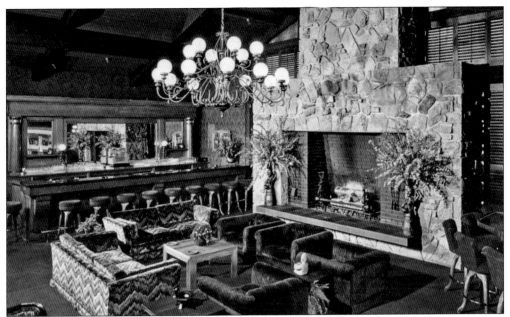

BRICK FIREPLACE AND LOUNGE. After Kahn died unexpectedly in 1973, ownership passed to his partner Morris Shenker, a lawyer for the Teamsters Union. Jimmy Hoffa stayed at the springs during this period, shortly before his mysterious disappearance. In 1977, the Securities and Exchange Commission charged Shenker with fraudulently obtaining $28.5 million in loans for Murrieta from union pension funds. The property went into bankruptcy. Several subsequent enterprises failed. (BR.)

TENNIS "PRO SHOP." In 1974, Rod Laver, the only man to win the Grand Slam of tennis twice at that time, and his fellow Australian Roy Emerson teamed up to develop a "tennis holiday." Tennis players from all over the world came for either a week or a half-week of intense tennis instruction, including strategy and etiquette. Besides practicing on the court, the clinic also instructed by video. (DRF.)

PUTTING GREEN. The ground-breaking ceremonies for the new Robert Trent Jones 18-hole golf course and clubhouse were held in April 1971. A news article stated, "A caravan of Hollywood movie, TV, and radio personalities, and press correspondents were enthusiastic." The estimated cost for the new facility was $2.5 million. The Pro Shop and Grill Room still serve the public today.

DRIVING RANGE. When the Teamsters Union built the golf course for the Murrieta Hot Springs Resort, they called on one of the world's most famous architects, Robert Trent Jones Sr., then in the twilight of his renowned career. The Southern California Golf Association (SCGA) course is still operating at 39500 Robert Trent Jones Parkway, Murrieta, and is now surrounded by thousands of homes. (TVHS.)

MOBILE HOME PARK. The Spring Knolls Mobile Park was master-planned by architects from Newport Beach. The facility included a 9,000-square-foot clubhouse with a private card room, reading rooms, sauna baths, and a billiard room. Three hundred and eighty-five home sites were developed in the newly excavated and terraced property overlooking the hotel and health spa. By 1971, a total of 150 of the home sites were sold. (MLB.)

SPRING KNOLLS MOBILE PARK. In addition to the main facility, a heated swimming pool and mineral pool were built in Spring Knolls. Landscape architect K. Kammeyer designed the property to accentuate the natural beauty of the rolling land. In 1972, a home site cost $9,950 to $25,000. Kammeyer also designed the landscaping at Pres. Richard Nixon's home in San Clemente. (MLB.)

An Alive Polarity Energy Balancing Session

NEW OWNERS. In 1983, a group called Alive Polarity bought the resort. The 300-member community turned the facility into a vegetarian, no-alcohol, no-tobacco, no-caffeine, no-telephone, and no-television commune. Members gave up their possessions after a three-year trial period. They followed a philosophy of a nonviolent life. (DPB.)

ALIVE POLARITY. Most of the members were in their 30s and had given up established careers for a lifelong commitment to the commune. They lived in the hotel rooms, ate in the cafeteria, and performed all the resort jobs. Their children attended an Alive Polarity school on the grounds. The neatly dressed people included credentialed teachers, registered nurses, and others with college graduate degrees. (DPB.)

ADVERTISING TO THE WORLD. Alive Polarity operated an aggressive marketing program advertising the spa in publications to attract visitors, not to convert them but to bring income to their compound. They advertised gourmet vegetarian meals, saunas, steam baths, facials, mud baths, and mineral water soaks in tiled tubs during stays from one night up to a month. Their vegetarian restaurant was a popular eatery for locals. (DPB.)

CANCER CLINIC. In 1975, R. J. Rudd, a self-proclaimed doctor of philosophy, an economist, and a Baptist minister, leased the hot springs. Rudd and his associates set up a clinic, promising to cure cancer patients through a diet of lemon juice and water. Desperate patients came for treatment from all over the United States. Three undercover investigative reporters were sent by *60 Minutes* to Rudd to "seek treatment" for one of them. Sheriff's deputies raided the clinic in September 1977, and Rudd was indicted for selling bogus shares in his scheme. The *60 Minutes* exposé, which also featured Mike Wallace grilling Rudd, aired twice during 1978. The cancer clinic venture failed, and the springs was abandoned for several years, except for a chiropractic office and Shakespeare's Bar and Grill. (BR.)

Seven
RESTORATION BY CALVARY

A NEW BEGINNING. Murrieta Hot Springs sprang back to life in 1995, when Calvary Chapel of Costa Mesa purchased it for use as a Bible College and conference center. They could have razed the buildings and started over, but the chief administrator, Pastor Chuck Smith, saw a historical treasure in the edifices that bridged the gulf of nearly a century. The walkway into the Bible College features the Maranatha dove logo. (DRF.)

A WARM WELCOME. Derek Rapolla, the chief guard, welcomes a visitor at the main entrance to the hot springs. Although the public is welcome to enter the bookstore and the grounds for special functions, the guarded entrance protects the privacy of students and conference attendees. The grounds are serene, beautiful, and safe. Previously, Calvary's Twin Peaks Conference Center near Lake Arrowhead was the home of the Bible College. (CCBC.)

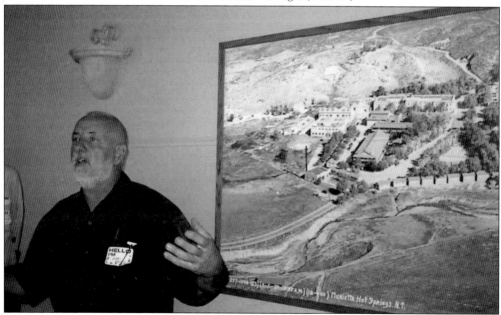

BUILDING ON THE PAST. Karl Bentz welcomed the Temecula Valley Historical Society to a luncheon and tour of the hot springs in August 2007. He stood next to an aerial view of the springs, reproduced from a vintage postcard. Several framed enlargements of vintage photographs grace the walls of buildings at the springs today. Lacking schematic site plans, the reconstruction crew relied on old photographs to identify locations of old structures. (DRF.)

WORSHIP BAND CLASS. Students at the Bible College have a choice between this class or a Sound and Recording class to equip them with skills to lead or assist in church worship services. The T-shirt worn by the guitarist in the foreground indicates he is a security guard. Each student is assigned to a volunteer job to complete Practical Christian Ministry requirements. (CCBC.)

A WOMEN'S DISCIPLESHIP MEETING. These women are leading worship for a weekly Sunday evening program that is open to the public at the sanctuary by the lake, built in the late 1990s. During these meetings, female staff members teach from the Scriptures. The photograph above this one was taken in the auditorium near the tennis courts. (CCBC.)

THE DINNER LINE. Supervised by head chef Sherri Stalder, students in Practical Christian Ministry prepare dinners of Mexican or Italian food, barbecue or teriyaki. The kitchen and cafeteria (above) are in the Administration Building, shown on page 88. Students receive three meals a day and have access to a snack bar at the coffeehouse on campus. (CCBC.)

MAKING SALAD. These two female students chop romaine lettuce for salad with gloved hands. Behind them, a poster advises them, "Let no one despise your youth. BE AN EXAMPLE to the believers in word and conduct, in love, in spirit, in faith, in purity." (CCBC.)

INTERNATIONAL STUDENTS, 2007. The man with the patterned shirt on the left is Gabriel Gwahenye from Tanzania. Second from the right is Olugbenga Ayokunle Olajide, or "Ayo" from the United Kingdom. Leaning over, at the far right, is Daniel Fox, also from the United Kingdom. Students from Peru, China, and Canada have also attended Calvary Bible College. Each semester, students print a theme on T-shirts, like the "Quiet Love" message in the foreground. (CCBC.)

COFFEEHOUSE. The coffeehouse, formerly the Frontier Bar, as seen on page 57, is now an upbeat place to meet together and for study. The coffeehouse is a favorite place for conference attendees to gather for the designer coffees and handmade desserts offered at reasonable prices. Eclectic artistic expressions of students adorn the walls. (CCBC.)

CLASSROOM "B." This image shows Lu Wing teaching during the spring semester of 2008. He gives instruction from the biblical books of Genesis, Leviticus, Numbers, and Hebrews. The school runs efficiently under the leadership of Dave Shirley, director. (CCBC.)

COLOSSIANS CLASS, FALL 2007. Jeff Christianson and his class pose for an al fresco session in the gazebo by the lake. Calvary Bible College enrolls about 600 students each semester for the two-year school. Students receive either a Bachelor of Biblical Studies or an Associate of Theology degree upon completion. (CCBC.)